1977 Hayward Annual

Current British Art
selected by Michael Compton, Howard Hodgkin
and William Turnbull

Hayward Gallery, London

Part One 25 May to 4 July
Part Two 20 July to 4 September

Arts Council of Great Britain

© Arts Council of Great Britain 1977
ISBN: 0 7287 0132 4

Exhibition organised by Tamar Burchill and Andrew Dempsey
Catalogue designed by Lloyd Northover Limited, London
Printed by Westerham Press Limited

Foreword

The idea of staging an annual exhibition of British art at the Hayward Gallery has developed out of previous exhibitions which took place at two-year intervals and included Anne Seymour's *The New Art* in 1972 and Andrew Forge's *British Painting '74*. An exhibition of this kind would have been held in 1976 had it not been precluded by the coincidence in the same calendar year of the large exhibitions of Islamic and American Indian art. At that time the committee which advises the Arts Council on its programme suggested that these exhibitions should take place annually. We therefore start a new series with the present exhibition and it has been possible, almost by way of making up for lost time in 1976, to extend the showing period so that the 1977 Annual can take place in two parts and include the work of more artists than will normally be practical.

As Michael Compton points out in his statement on behalf of the selectors, the ground rules for the Hayward Annuals are extremely simple. They will be chosen by a different group of individuals each year and will show recent work by a limited number of artists, a limitation which results from the decision to show each artist fully. As a series we hope that the Annuals will present a cumulative picture of British art as it develops. The 1978 Annual will be selected by Rita Donagh, Tess Jaray, Liliane Lijn, Kim Lim and Gillian Wise.

We would like to express our warm thanks to Michael Compton, Howard Hodgkin and William Turnbull whose work for this first exhibition has extended beyond selection. They have advised both on the presentation of the exhibition itself and on the contents of this catalogue. It is at their suggestion that the exhibition contains an information area and the catalogue a minimum number of words in favour of a maximum number of illustrations. We are also grateful to the many lenders to the exhibition.

Joanna Drew
Director of Exhibitions

Introduction

The selection of artists for this exhibition is based on one essential presumption: it is only the first of a series of exhibitions of British art, executed in the previous two or three years, that will be held annually, that will be of approximately the same type and scale and that will be chosen by different groups of selectors. The choice may, therefore, be a purely personal one.

In discussing what kind of an exhibition we could jointly select, my colleagues used the similar phrases 'the artists I know about and believe in' and 'within our knowledge and prejudices'. We quickly resolved that the selection of any artist should be unanimous. This was adhered to in the event, with a small number of exceptions where an artist was selected on the basis of a very strong vote from two selectors and at least an assent from the third. I would go so far as to say that a very large proportion of the artists to whom the phrases quoted above apply both unanimously and with a high degree of force are in the exhibition. The omissions include artists who were unwilling or unable to take part and a few whom the Arts Council are exhibiting on a large scale at a date very close to the Annual.

The selection was made on the basis of the selectors' view of the artist's work generally and not of individual works of art.

I was pleased that the Arts Council followed my suggestion of encouraging artists who select such exhibitions to show with those whom they select and that my colleagues in this instance were persuaded to do so. A mutual knowledge, belief in and favourable prejudice, exactly like that governing the selection of other artists, was a natural precondition for artists to work together in this way.

We have made no attempt to illustrate or propagandise a theme or development in art as Anne Seymour did in her excellent show *The New Art*; on the other hand we have not sought to make a representative sample of styles, demographic groups, media or subject matter nor to take into account other people's views. No aspect of art has been omitted categorically although visitors will easily distinguish aspects which are absent or under-emphasised, in their judgement. Indeed the selection is flagrantly partial. Equally no artist has been omitted just because he or she is well known and no artist has been included because he or she is little known or needs to be encouraged. We have not even gone out to search for new talent because the kind of 'belief in' an artist accepted as the basis of selection does not arise in three individuals instantly and simultaneously but with experience of their work unstressed by the requirement of voting for inclusion in such a show.

The number chosen is limited not only by the level of common assent but by the idea that each one should have room to establish his own character as an artist. The spaces are of roughly similar size and more or less self-contained. They are arranged so as to inhibit any tendency to read into the selection any argument or attempted paradigm, just as none is expressed in this catalogue. On the contrary, the juxtaposition of one artist with his neighbours has been carefully considered so that each artist would be seen as an individual.

We have thought it worthwhile to devote a larger than usual proportion of the space in the gallery to a centre where visitors can obtain more information about the artists in the form of slides, photographs, biographical and bibliographical material.

Michael Compton

Part One
25 May to 4 July

Frank Auerbach
Anthony Caro
Patrick Caulfield
Bernard Cohen
Hamish Fulton
Nigel Hall
John Hoyland
Allen Jones
John Latham
Kim Lim
Kenneth Martin
Keith Milow
Nicholas Monro
Peter Phillips
William Turnbull

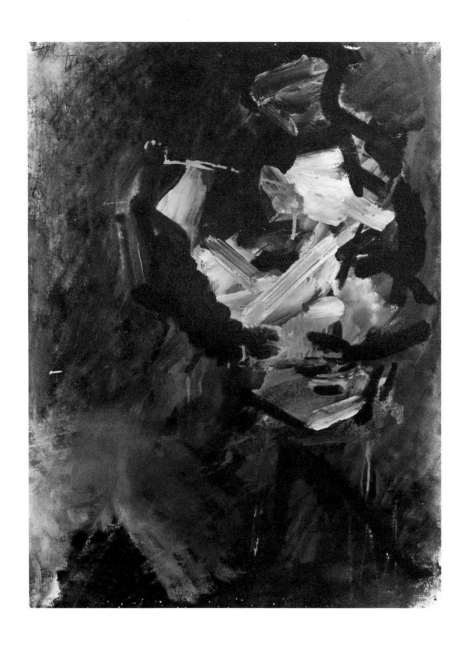

Portrait of Sandra 1974
77.5 × 56 (5)

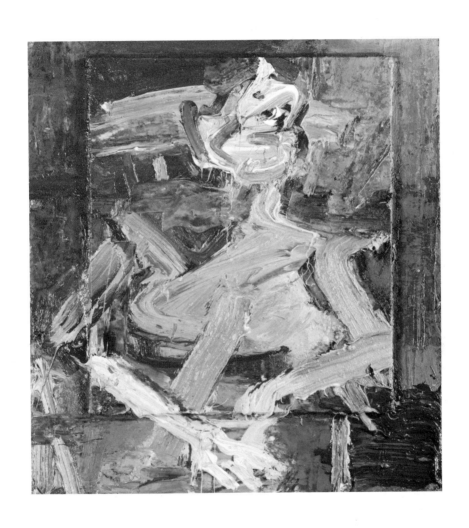

Portrait of J.Y.M. Seated 1976
50.8 × 45.8 (4)

Tree at Tretire with Geese 1974–75
76.2 × 75 (9)

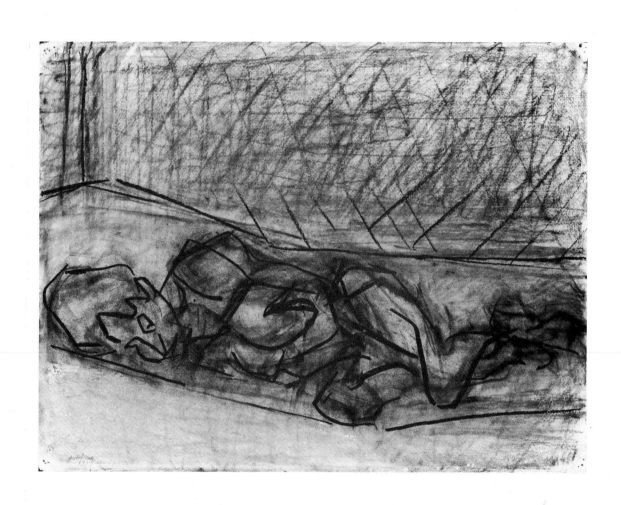

Reclining Nude 1976–77
56 × 78.2 (16)

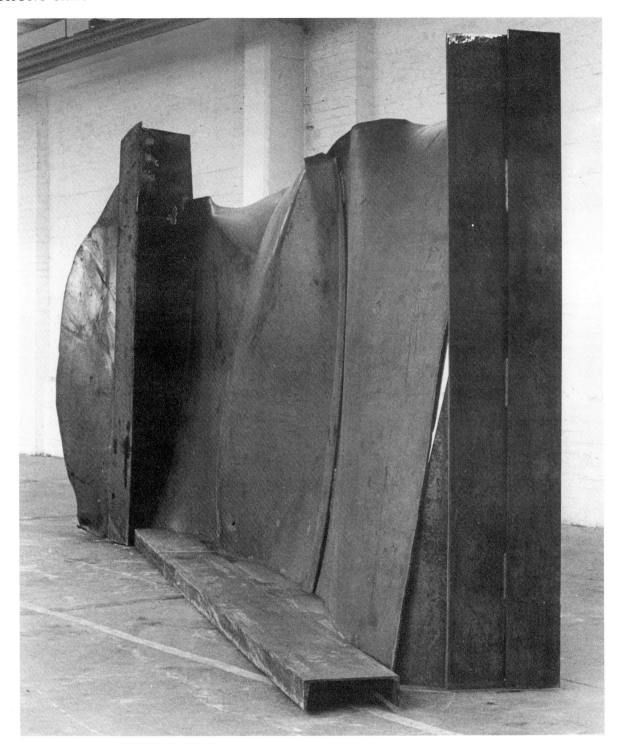

Tundra 1975
272 × 551 × 223.5 (17)

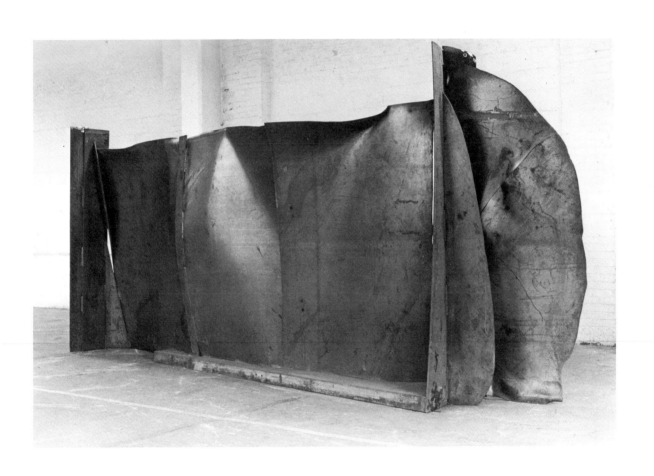

Tundra 1975
272 × 551 × 223.5 (17)

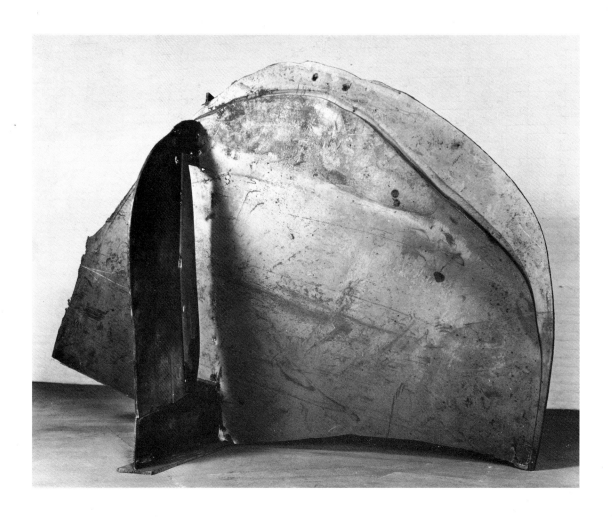

Footprint 1975
(sculpture photographed under construction)
216 × 302 × 167 (18)

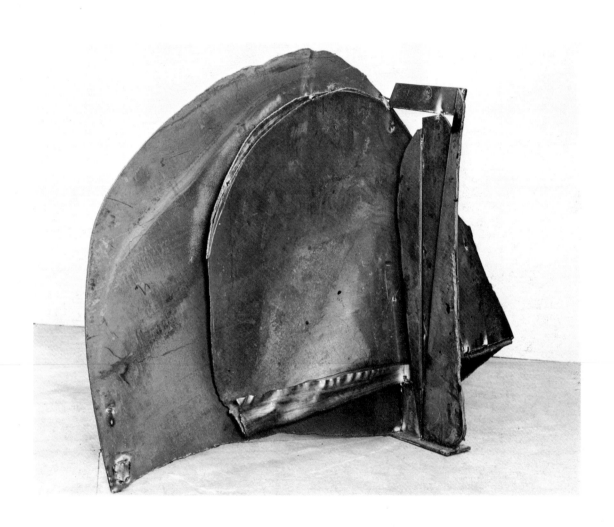

Footprint 1975
(sculpture photographed under construction)
216 × 302 × 167 (18)

Villa Plage 1970
366 × 152.4 (19)

Foyer 1973
213.5 × 213.5 (20)

In My Room 1974
274.5 × 274.5 (21)

Paradise Bar 1974
274.5 × 213.5 (22)

Representative 1974
274 × 137 (28)

Somewhere Between 1975
152 × 305 (30)

Resting Place 1975
213.5 × 213.5 (31)

Things Seen 1975–77
182.9 × 182.9 (32)

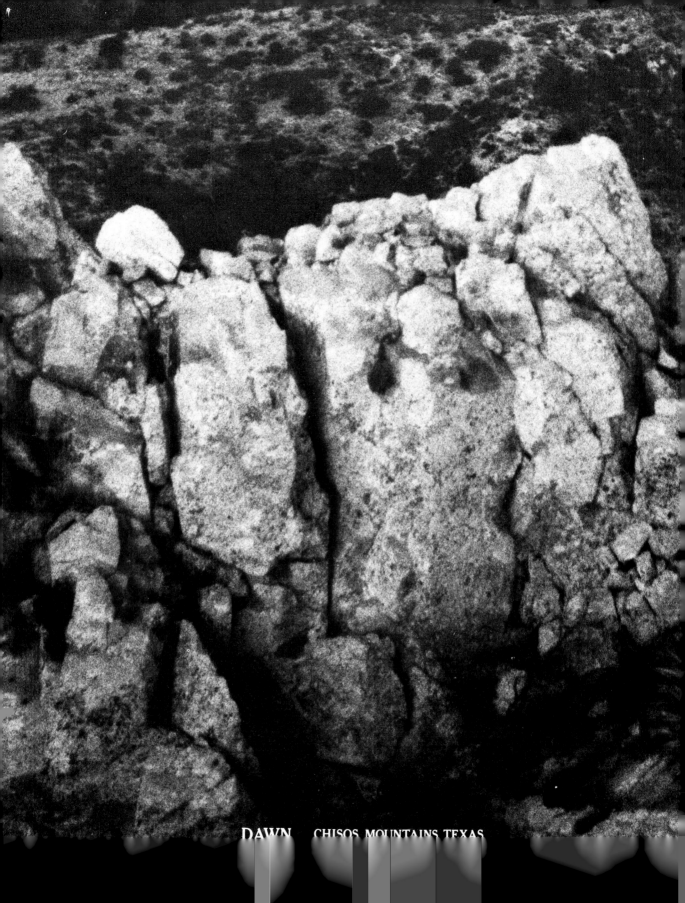

DAWN CHISOS MOUNTAINS TEXAS

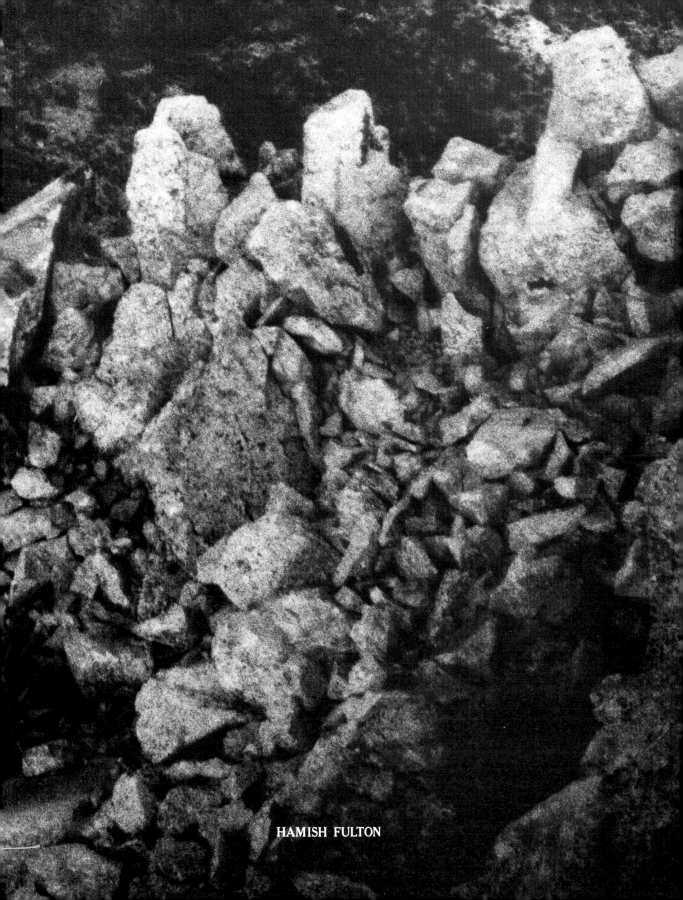

HAMISH FULTON

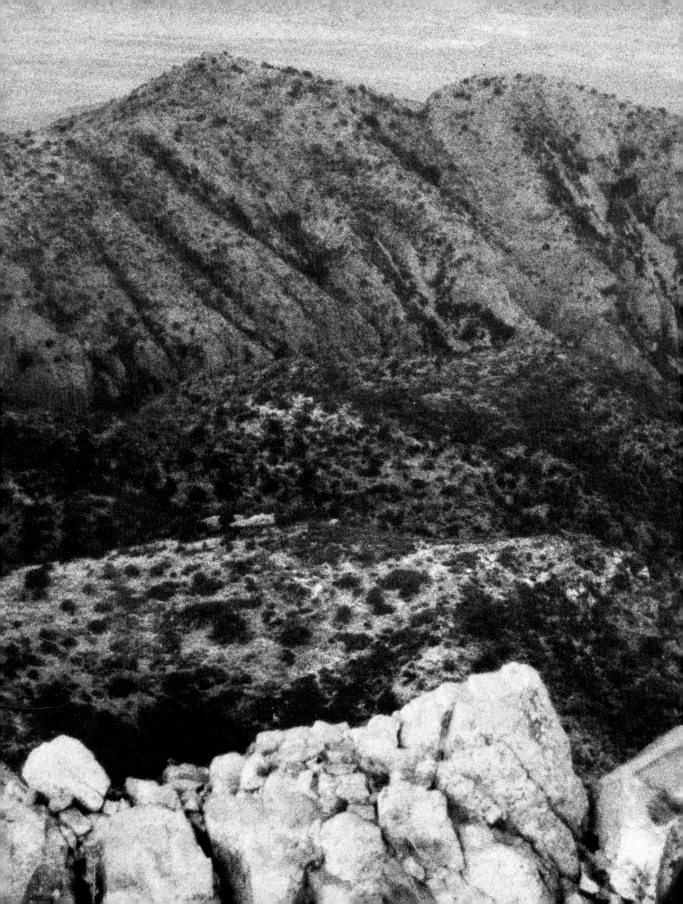

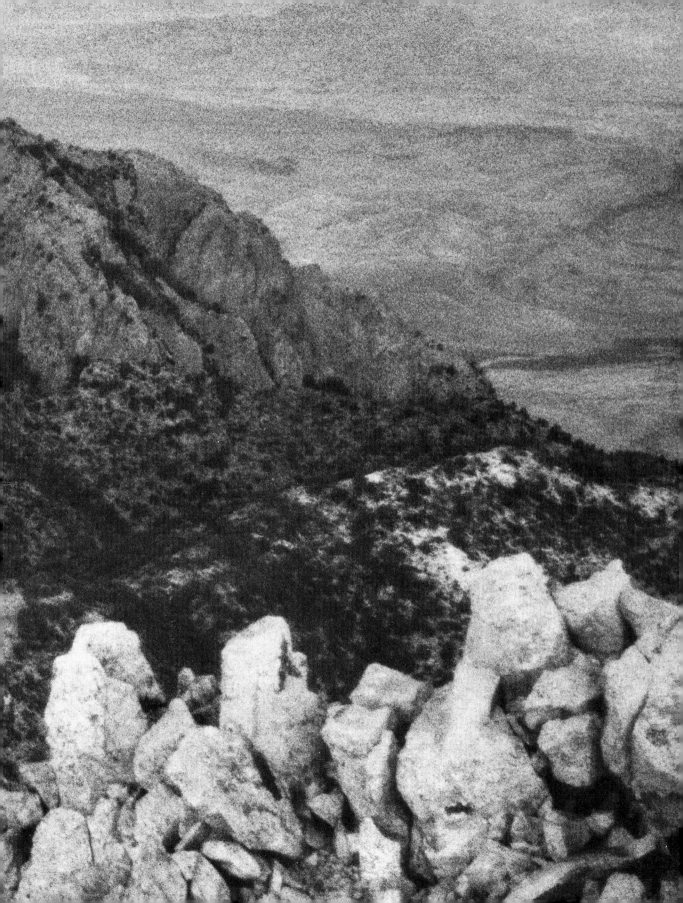

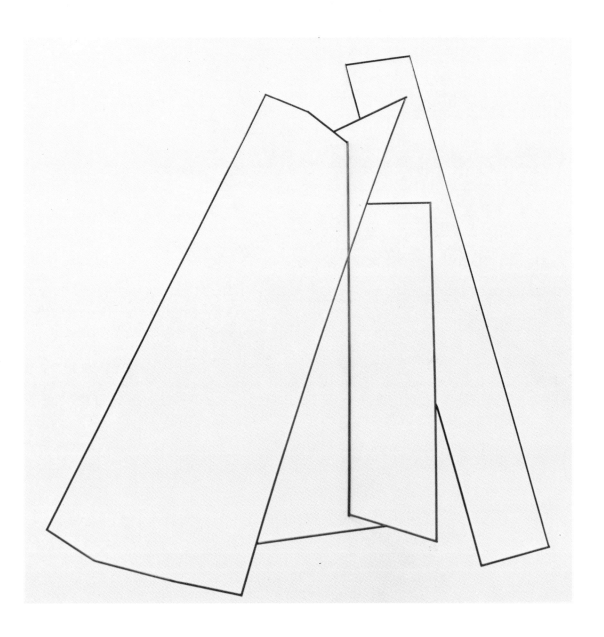

Four 1976
251.4 × 222.4 × 83 (41)

Multiple Fracture III 1976
33 × 173 × 46.9 (45)

Yellow Interior 1976
147.3 × 171.3 × 69 (42)

Multiple Fracture II 1976
204.4 × 66 × 71.1 (44)

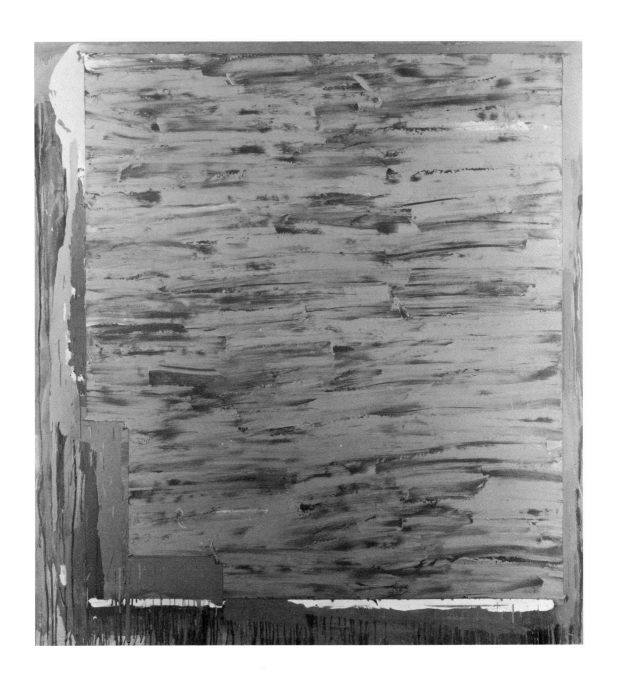

7.4.76 (Calypso)
244 × 213.5
(not exhibited)

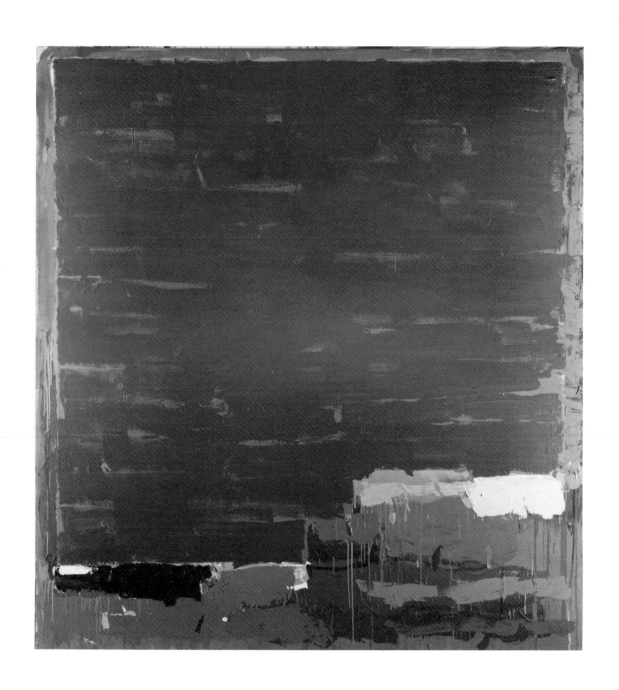

2.6.76 (Limen)
228.6 × 213.4 (53)

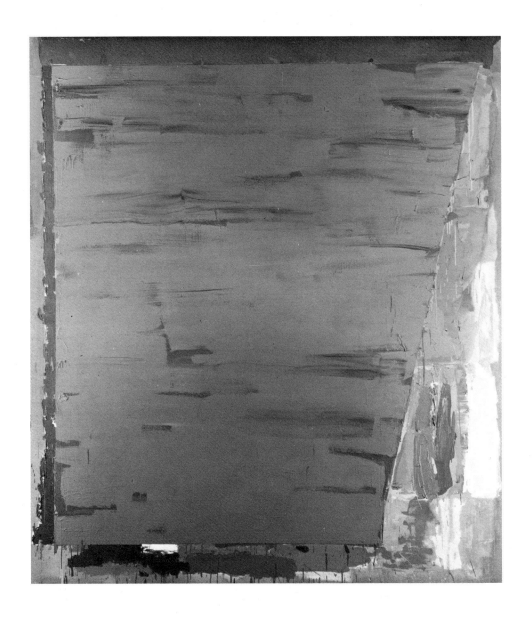

23.9.76 (Vale)
228.6 × 203.2 (54)

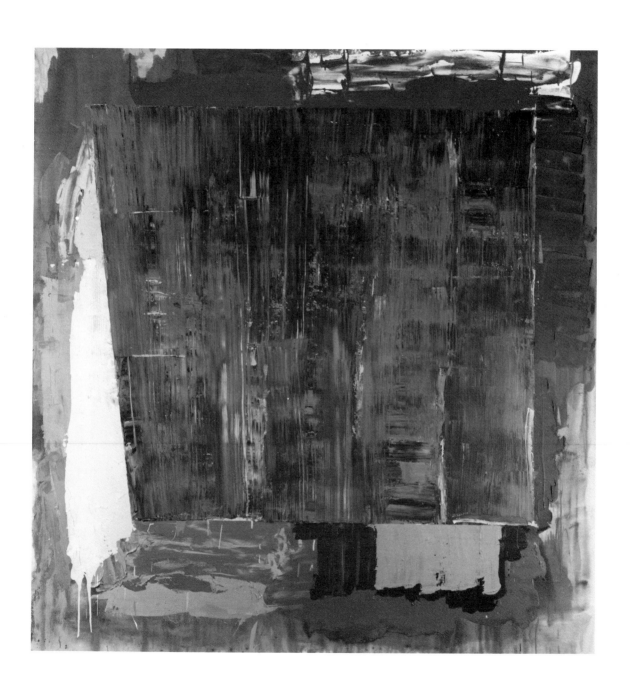

3.2.77 (Citar)
243.8 × 228.6 (55)

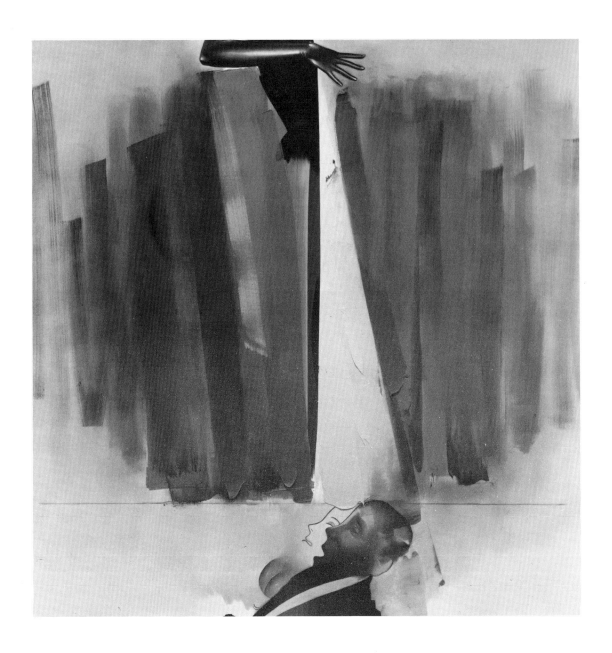

X-Pose 1976
183 × 183 (62)

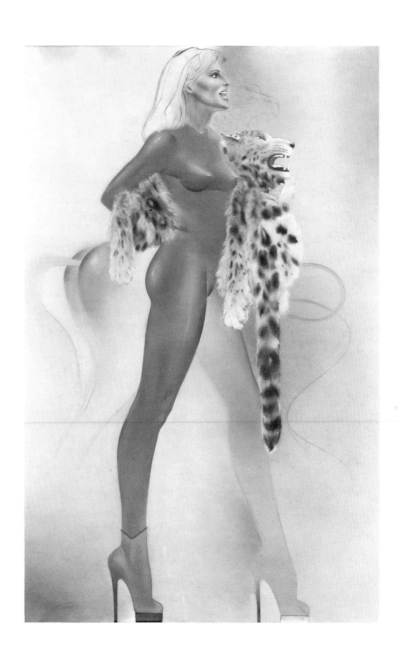

Leopard 1976
183 × 122 (60)

Eyes Front 1976
183 × 183 (58)

Grand Opening 1976
244 × 122 (59)

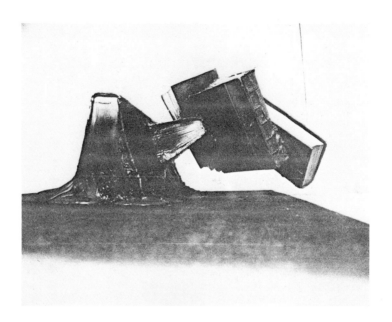

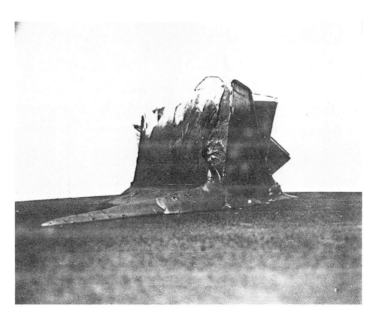

MFI bing 1976 (not exhibited)

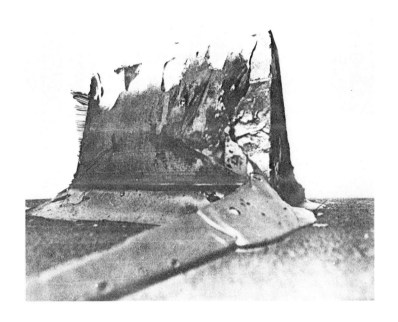

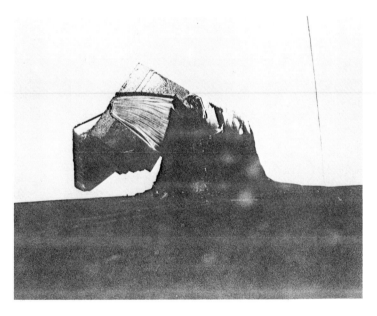

The Life and Death

e the same the same the same the same the same the same the same the same
the same the same the same the same the same the same the same the same th
e same the same the same the same the same the same the same the same the
SAME THE SAME THE SAME THE SAME THE SAME THE SAME THE SAME
SAME THE SAME THE SAME THE SAME THE SAME THE SAME THE SAME
AME THE SAME THE SAME THE SAME THE SAME THE SAME THE SAME T
SAME THE SAME THE SAME THE SAME THE SAME THE SAME THE SAME
AME THE SAME THE SAME THE SAME THE SAME THE SAME THE SAME T
ME THE SAME THE SAME THE SAME THE SAME THE SAME THE SAME TH
E THE SAME THE SAME THE SAME THE SAME THE SAME THE SAME THE
E THE SAME THE SAME TYE SAME THE SAME THE SAME THE SAME THE
THE SAME THE SAME THE SAME THE SAME THE SAME THE SIME THE SI
E SIME THE SIME THE SIME THE SIME THE SIME THE SIME THE SIME TH
THE SIME THE SI M THE SEME TH

of Great Uncle

ame the same the same
e the same the same th
the same the same the
AME THE SAME THE
SAME THE SAME THE S
AME THE SAME THE
AME THE SAME THE S
AME THE SAME THE SA
ME THE SAME THE SAM
E THE SAME THE SAM
THE SAME THE SAME
E SIME THE SIME TH
E THE SIME THE SIME

Note: for those interested in the fate of Great Uncle's estate the work of Skeles the best introduction. The Atheneum mathmaker's greatest contribution to a study of the subject was his analysis of the phonon. Primarily a measure, of the difference between what you expect and what actually happens the phonon ramified the whole Greek pronoun until it became confused and mustified by geometers and others whose work it somewhat resembled. Skeles is by way of being the father of Greek drama — after it became clear that the megaphonon is sure to be either a colossal joke or else total disaster. There followed a phononological interpretation of just about any piece of pie you care to open up, most interesting for us today perhaps being the theory of unmechanised gubernation. In spite of wide confusion the phonon reappears as an item of News. It is imperative to consider that the notion of the primitive quant of energy used in the physic that is applied today is in fact a misplacement of judgement, it being the EFFECT of a primitive news item.

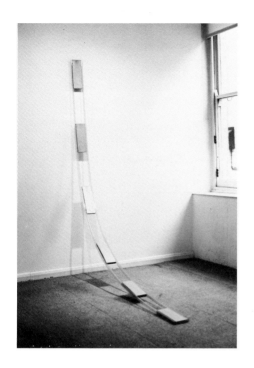

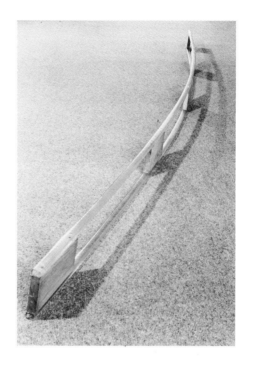

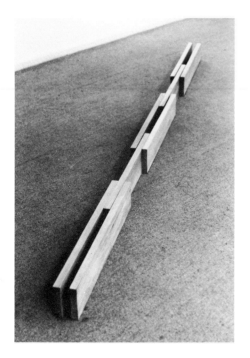

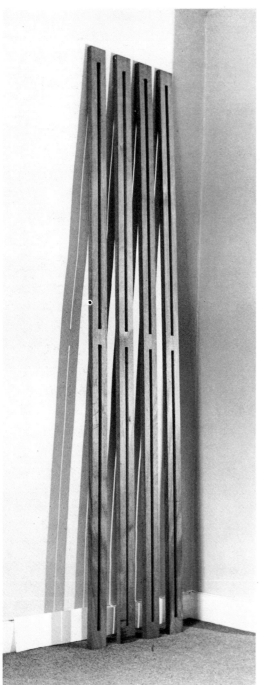

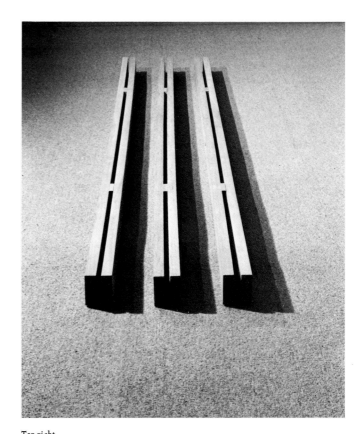

Above
Interstices II 1977
289.5 (76)

Top right
Interstices III 1977
289.5 (77)

Bottom right
Interstices 1977
289.5 (77)

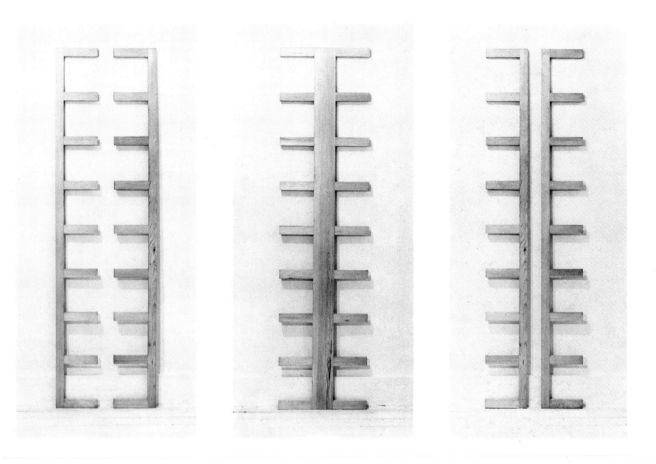

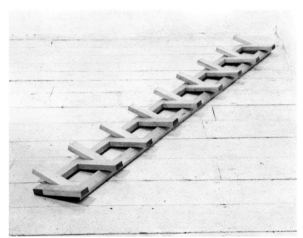

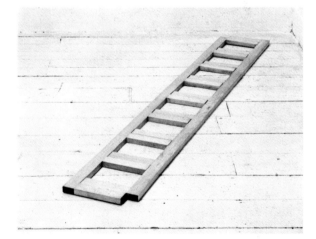

Top left
Intervals IIb 1973
182.8 (68)

Top centre
Intervals I 1973
182.8 (66)

Top right
Intervals IIa 1973
128.8 (67)

Bottom left
Intervals IIc 1973
182.8 (69)

Bottom right
Intervals IIe 1973
182.8 (70)

Four drawings from the series
commenced July 1976
Each 41.9 × 29.8 (87)

Order and Change (black) 1977
91.5 × 91.5 (86)

Chance, Order, Change 3 (black) 1977
91.5 × 91.5 (85)

KEITH MILOW

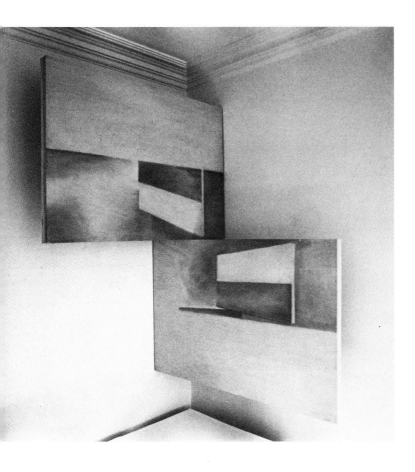

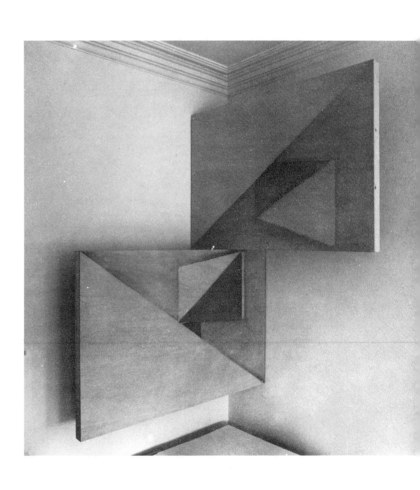

GREEN REBUS
1976
162.4 × 122 × 122 (90)

KEITH MILOW

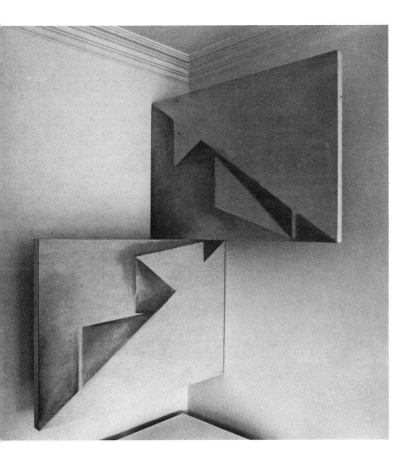

F
R
O
ANNUL
T
1976
162.4 × 122 × 122 (92)

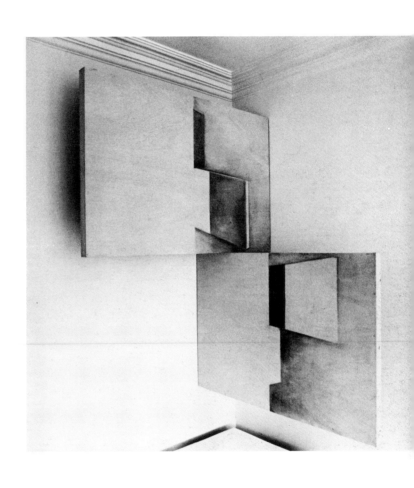

R
E
B
ANNUL
S

1976
162.4 × 122 × 122 (91)

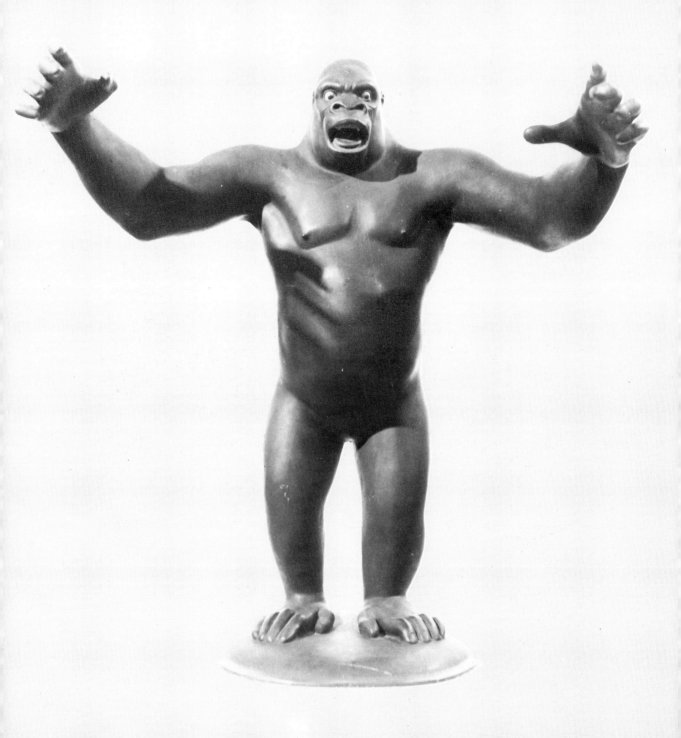

Maquette for King Kong 1971–72
100.2 × 86.3 × 60.9 (97)

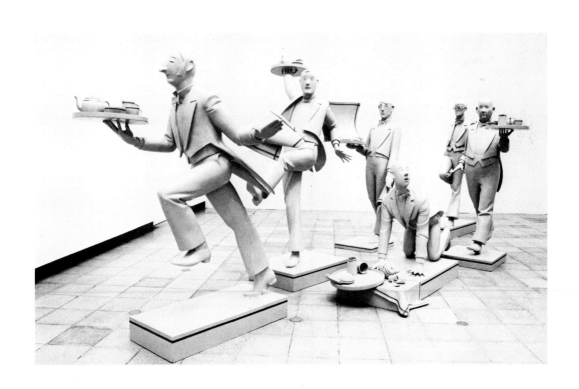

Waiters Race 1975
226 × 761 × 182.8 (100)

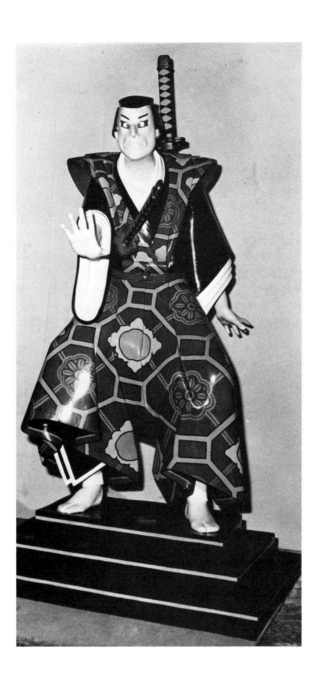

Samurai Warrior 1976
210.8 × 116.8 × 81.2 (102)

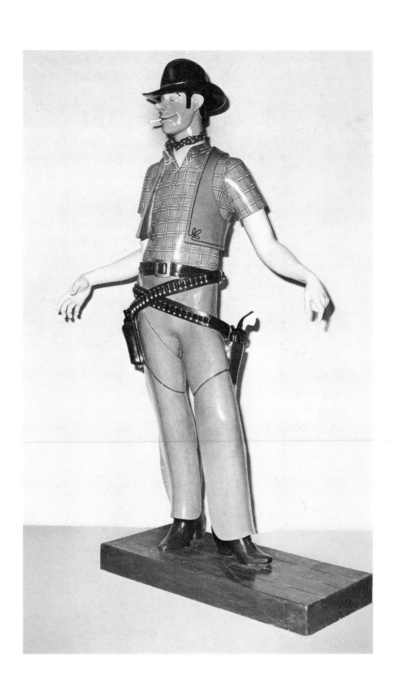

Dude Cowboy 1976
195.5 × 126.9 × 40.6 (101)

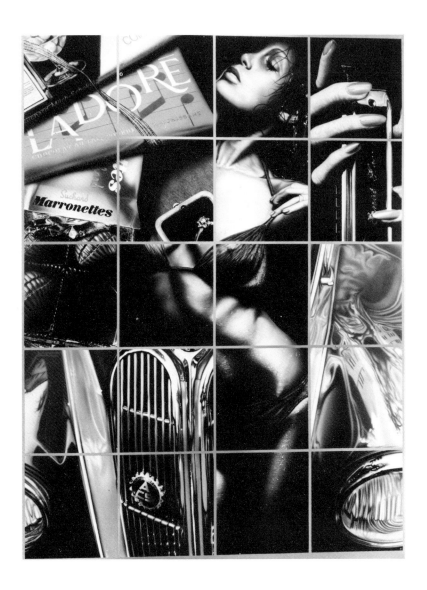

La Doré 5 × 4 1975
200 × 150 (106)

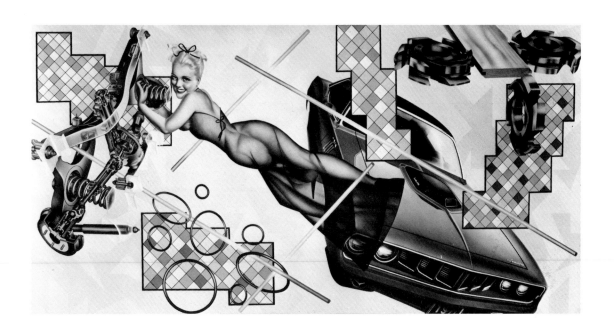

Art-O-Matic/Cudacutie 1972
200 × 400 (103)

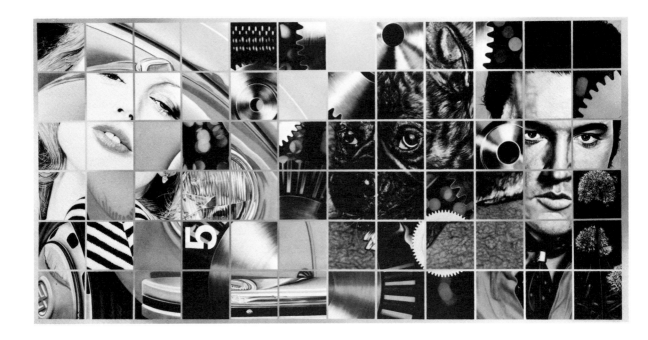

Mosaikbild 6 × 12 1974
182 × 365 (105)

No Focus Frames 1967–77
220 × 120 (108)

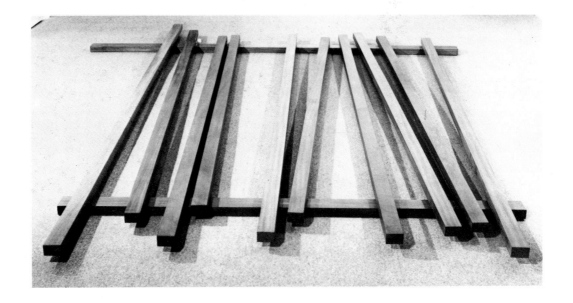

Random 1971–72
10.1 × 276.8 × 380 (110)

No. 3 – 1976
177.7 × 177.7 (115)

No. 12 — 1976
152.3 × 152.3 (117)

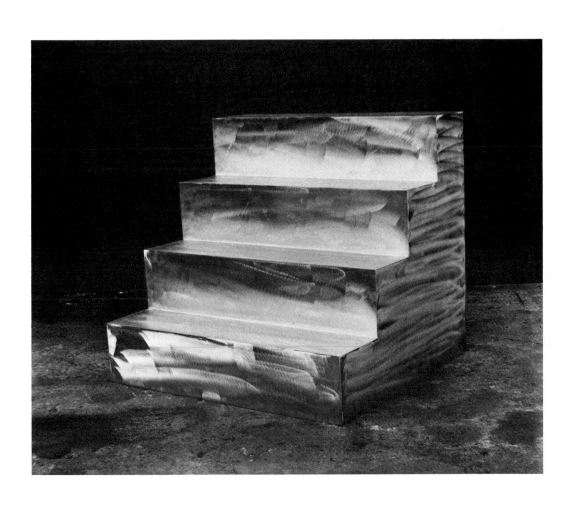

Steps 1967–72
91.4 × 91.4 × 101.5 (111)

Part Two
20 July to 4 September

Peter Blake
Stuart Brisley
Stephen Buckley
Victor Burgin
Michael Craig-Martin
Robyn Denny
Barry Flanagan
Anthony Hill
John Hilliard
David Hockney
Howard Hodgkin
R. B. Kitaj
Bob Law
Eduardo Paolozzi
The Theatre of Mistakes

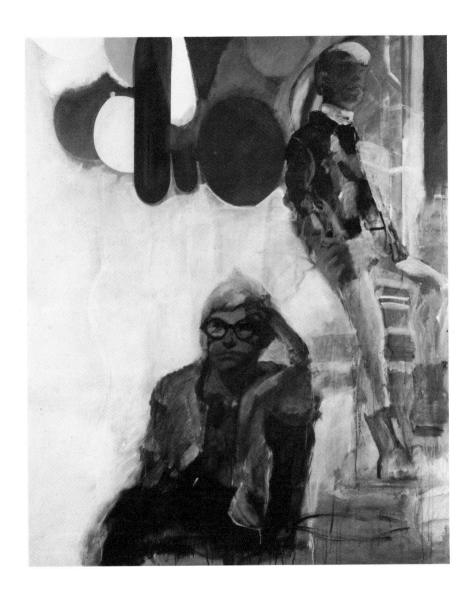

David Hockney in a Hollywood-Spanish Interior 1964
(still in progress)
182.9 × 152.4 (120)

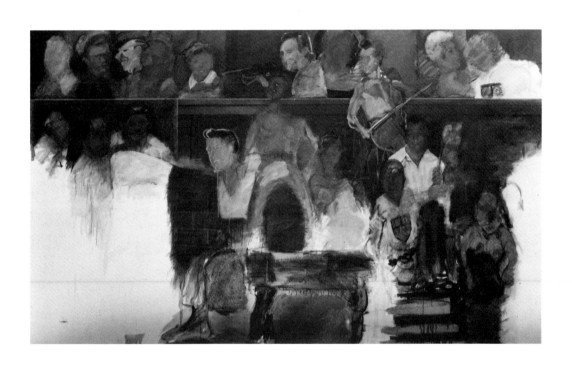

Sword Fight 1964
(still in progress)
182.9 × 304.8 (121)

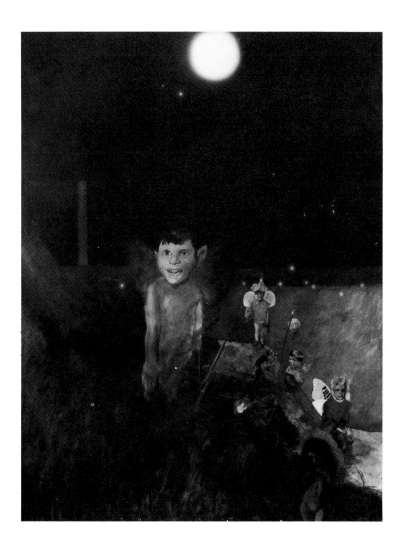

Puck, Peaseblossom, Cobweb, Moth and Mustardseed
1969 (still in progress)
99.1 × 76.2 (123)

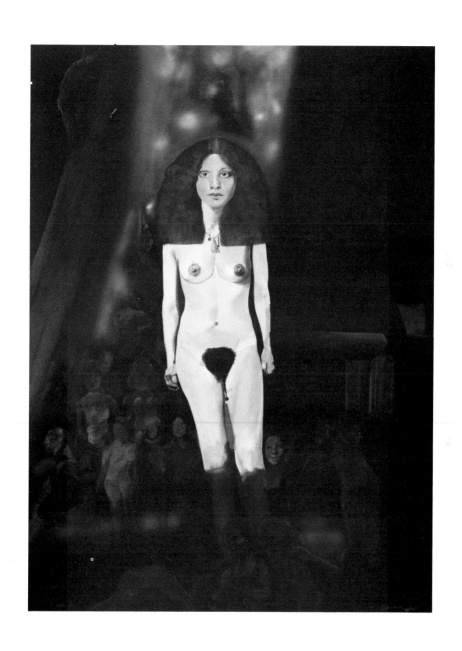

Titania 1976
(still in progress)
121.9 × 91.4 (124)

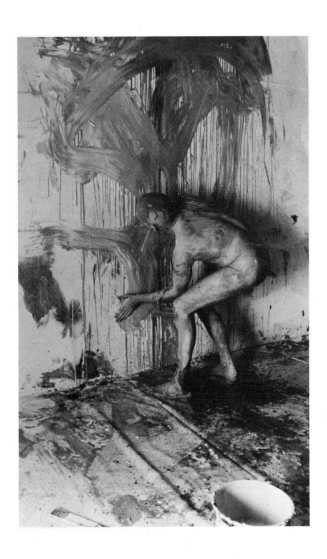 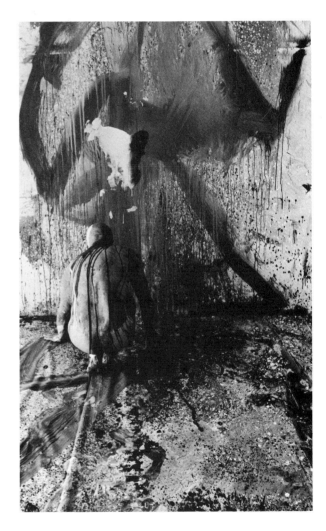

Moments of Decision in Decision 1975
(Brisley/Haslam)
Teatra Studio, Palac Kultury Inauki, Warsaw

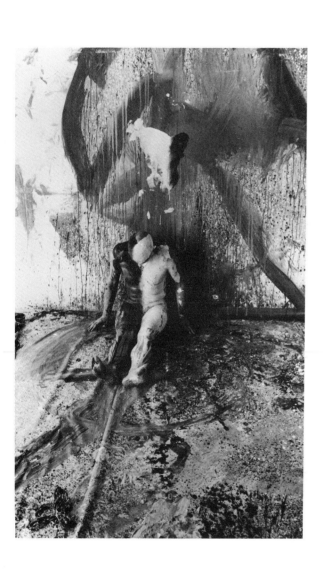

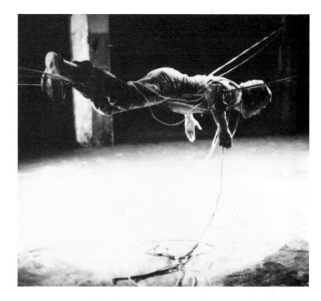

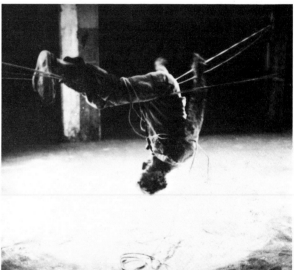

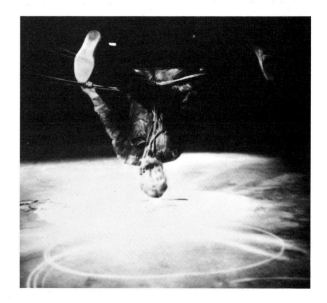

Right
26 Hours
Experimental Art Foundation, Adelaide,
South Australia, 1976

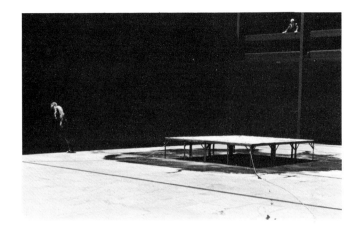

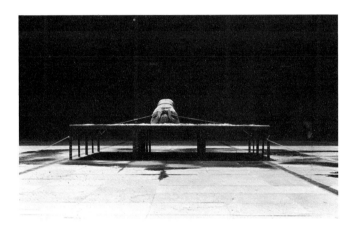

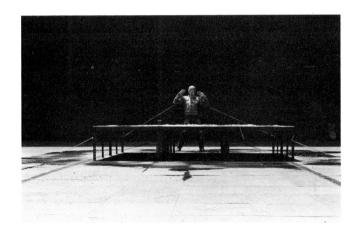

Weather Work 1976
National Gallery of Victoria,
Melbourne, Australia

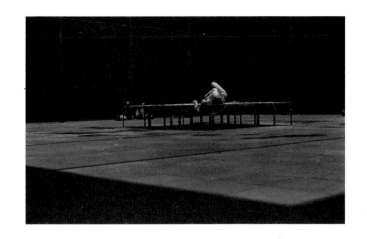

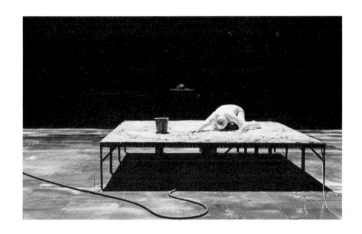

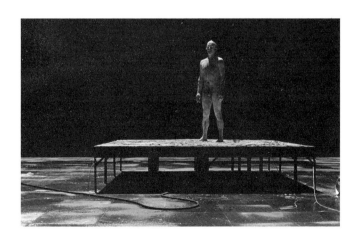

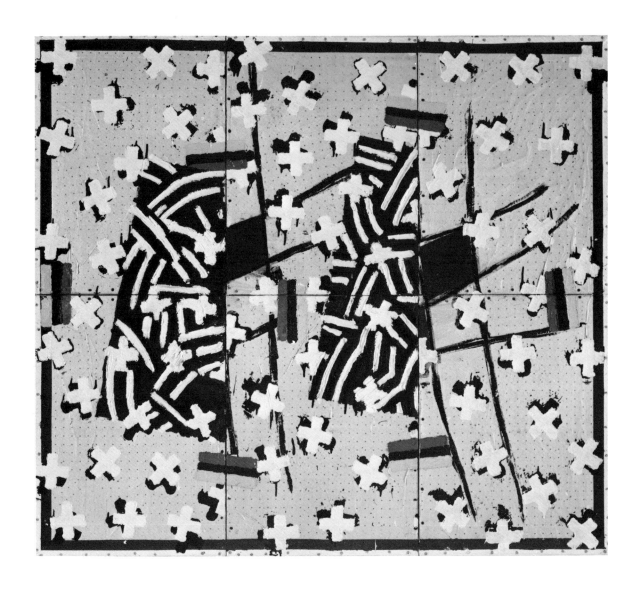

Akenside 1974
157.4 × 178.4 (126)

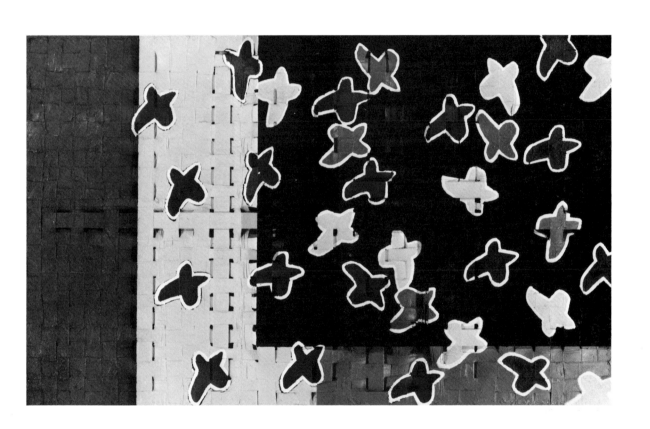

Dancers 1975
152.3 × 253.9 × 10.1 (129)

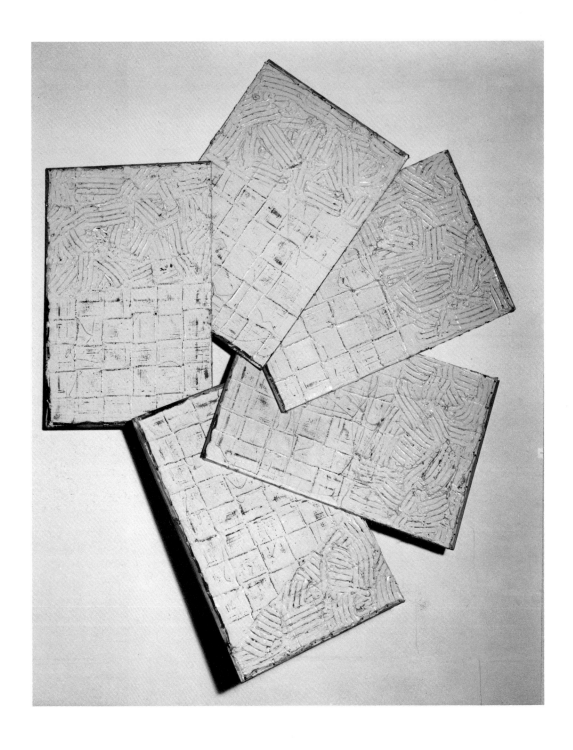

Head of Young Girl No. 7 1975
208.2 × 170.1 (128)

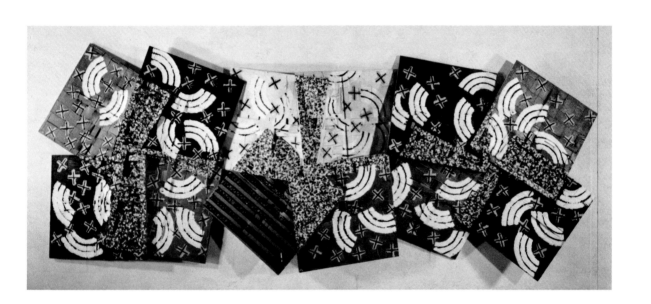

La Manche 1974
182.8 × 426 (127)

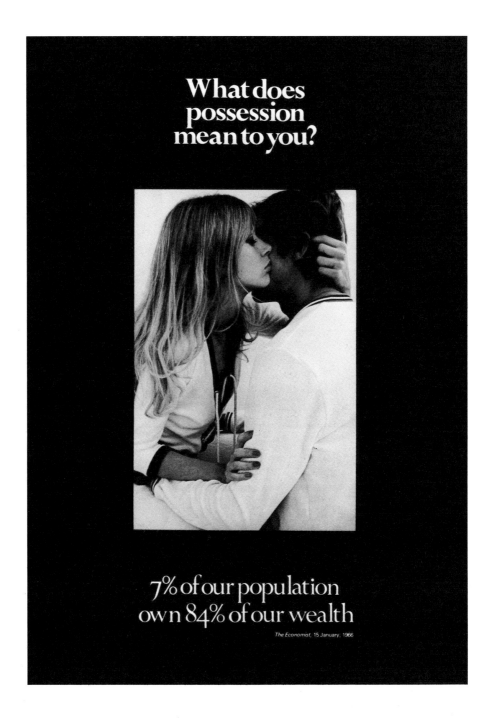

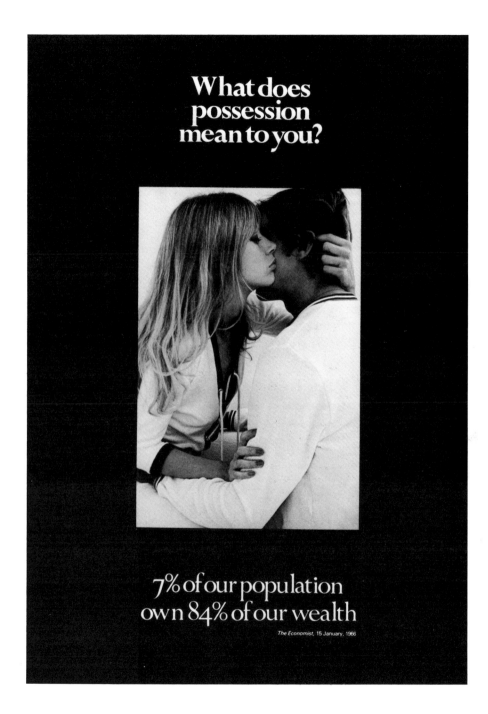

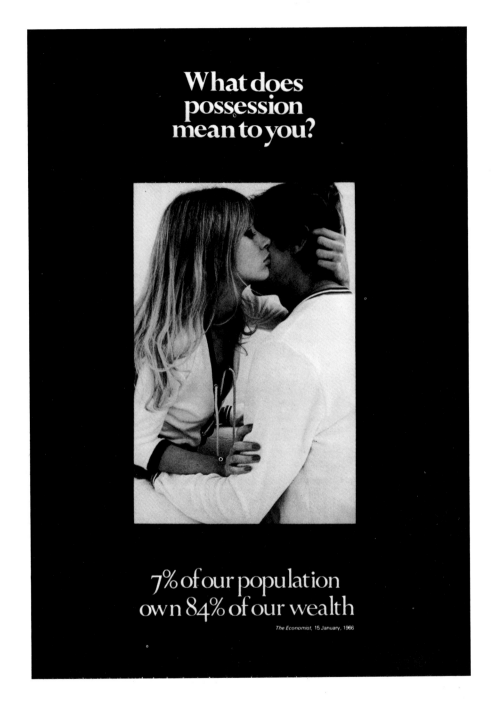

What does possession mean to you?

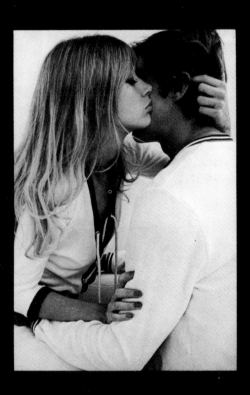

7% of our population own 84% of our wealth

The Economist, 15 January, 1966

Untitled painting No.1 1976
122 × 122 (131)

Untitled painting No. 2 1976
122 × 122 (131)

Untitled painting No.3 1976
122 × 122 (131)

Untitled painting No.4 1976
183 × 183 (131)

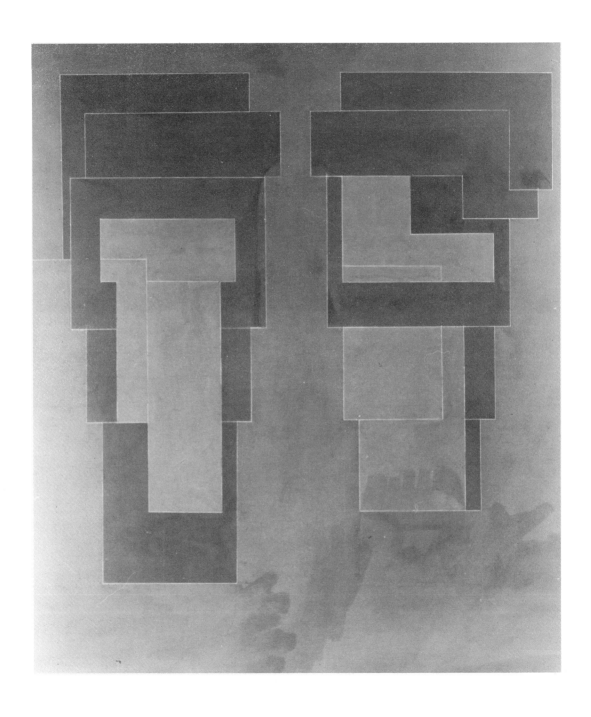

Travelling 1 1976–77
(unfinished)
213.4 × 182.8 (132)

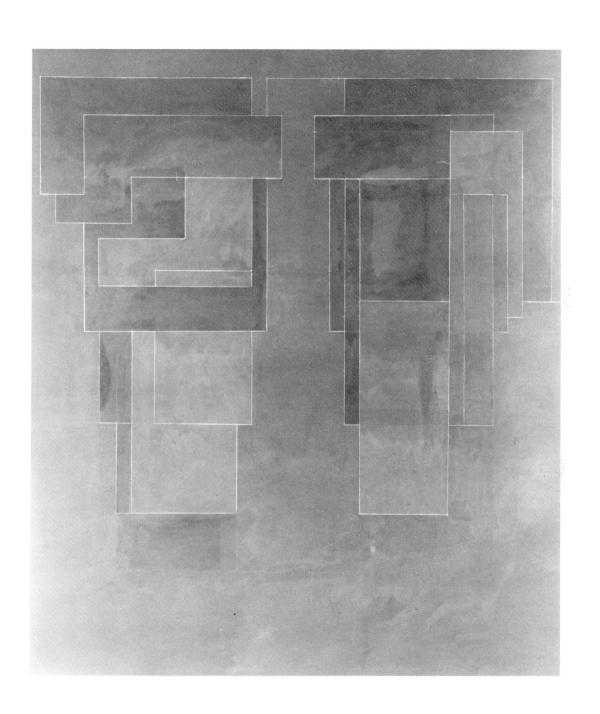

Travelling 2 1976–77
(unfinished)
213.4 × 182.8 (133)

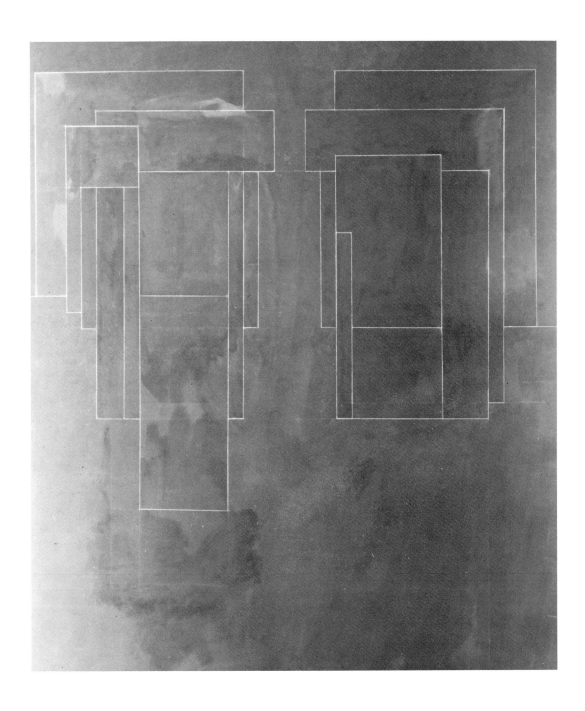

Travelling 3 1976–77
(unfinished)
213.4 × 182.8 (134)

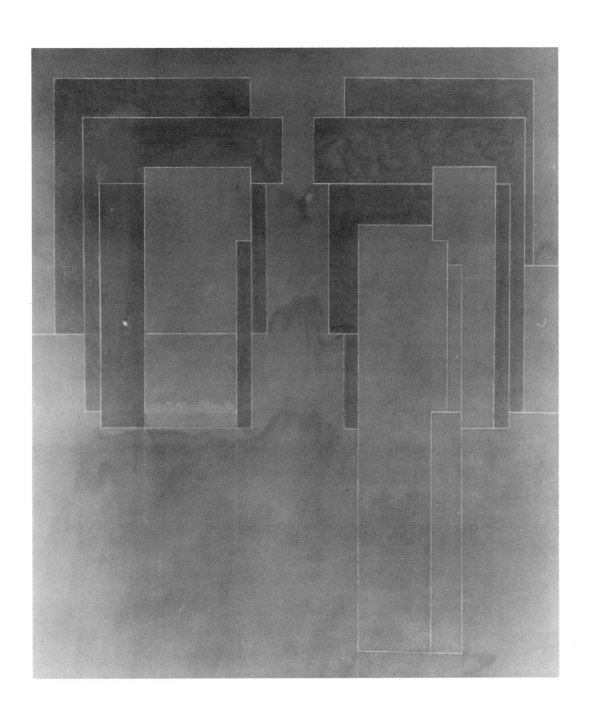

Travelling 4 1976–77
(unfinished)
213.4 × 182.8 (135)

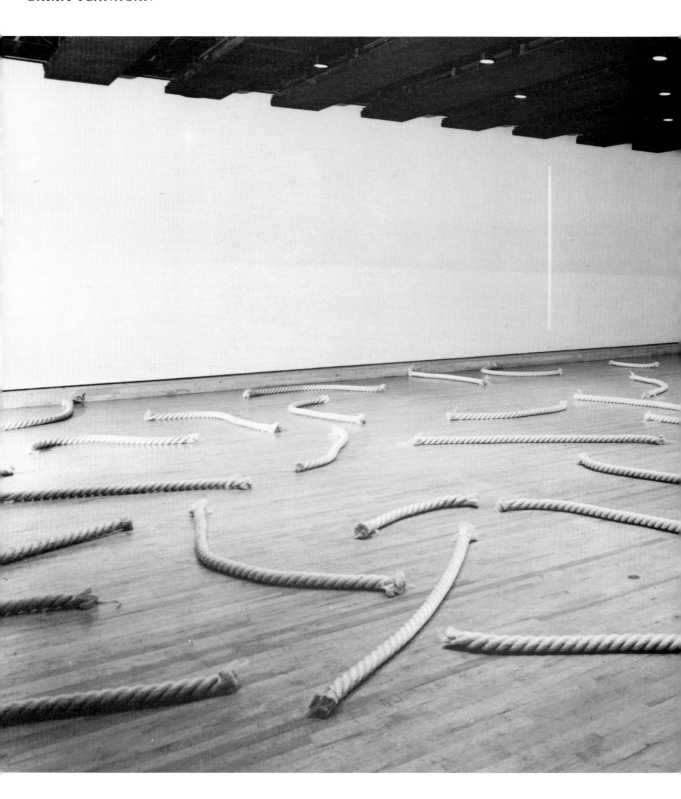

Hayward Installation 1 1969

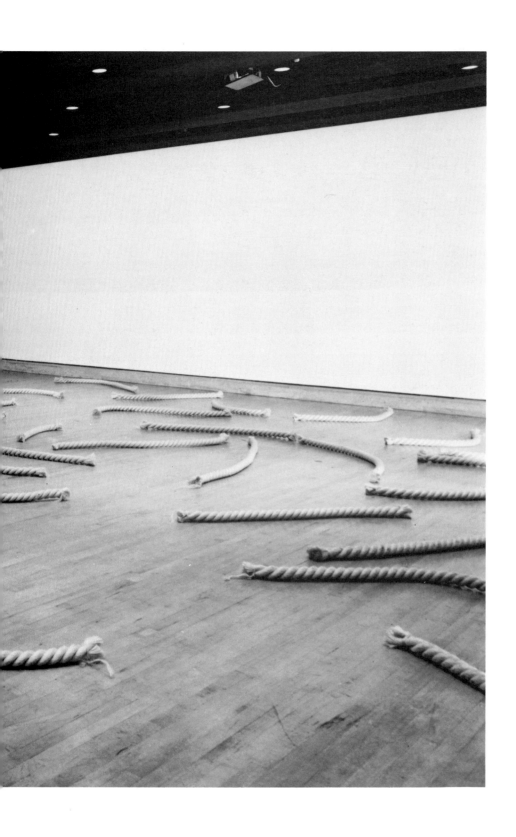

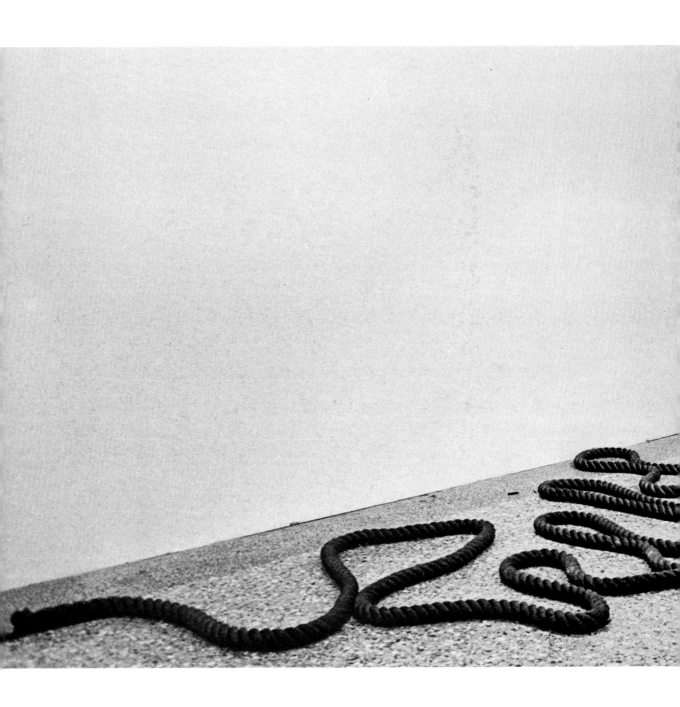

Four casb 2'67
Ringl 1'67
Rope (GR 2 SP60) 6'67

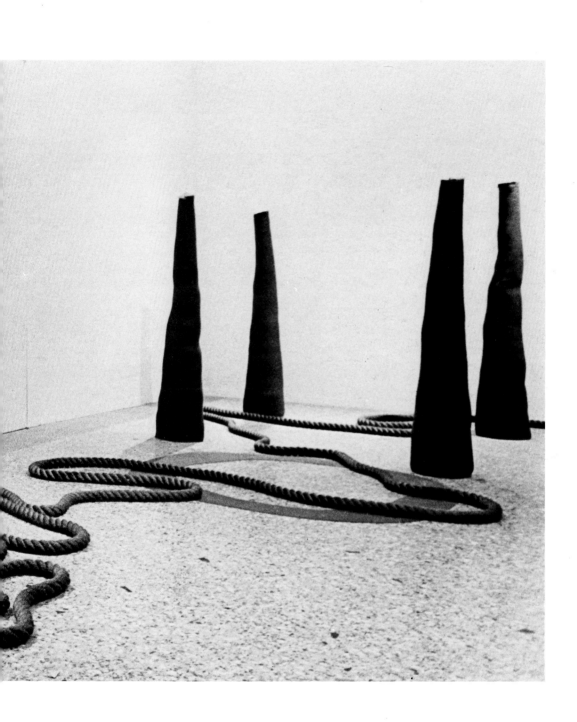

The Nine – Hommage à Khlebnikov No. 2 1976
91.4 × 91.4 (139)

The Nine – Hommage à Khlebnikov No. 3 1976
91.4 × 91.4 (140)

Linear Rebis 1976–77
81 × 76 (145)

Kupka's Tower (Rebis series) 1976–77
81 × 76 (143)

HORSE-CHESTNUT LEAVES IN AN AUTUMN POND

Untitled 1976
Set of 3 photographs each 60.9 × 81.2 (146)

HORSE-CHESTNUT LEAVES IN AN AUTUMN POND

HORSE-CHESTNUT LEAVES IN AN AUTUMN POND

JOHN HILLIARD

Untitled 1976
Set of 3 photographs each 60.9 × 81.2 (147)

The most plausible theory is that Mr Cameron, whose body was discovered entangled in a tree at the edge of the lake, may have died after jumping without a parachute at very low altitude, perhaps believing he was about to crash into the hill. But an extensive search by police has so far failed to find any trace of the plane (a single-engine Cessna) in which the former Battle of Britain pilot was last seen alive.

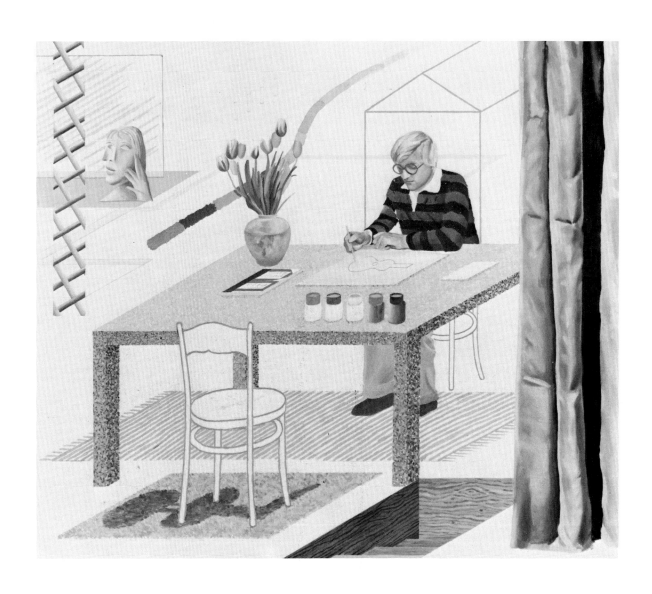

Self-portrait with Blue Guitar 1977
152 × 183 (151)

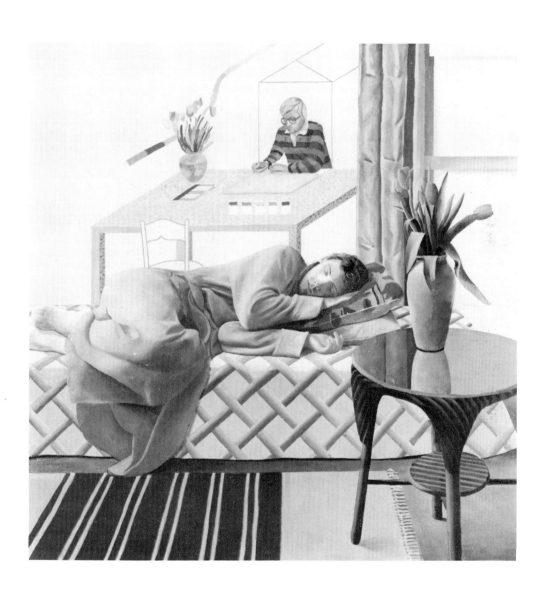

Model with Unfinished Self-portrait 1977
152×152 (150)

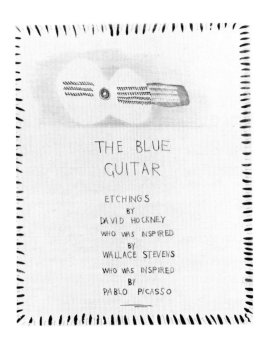

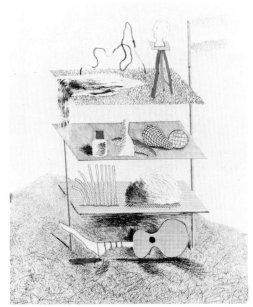

Serenade

Discord Merely Magnifies

The Poet

The Blue Guitar
(A selection of etchings from a portfolio of 20)
1976–77
Each 35 × 42.5 (152)

Parade

Tick it, Toch it, Turn it True

A Picture of Ourselves

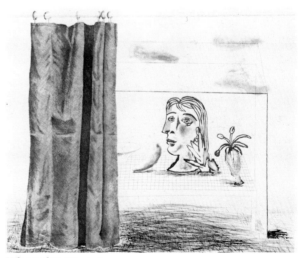

What is this, Picasso?

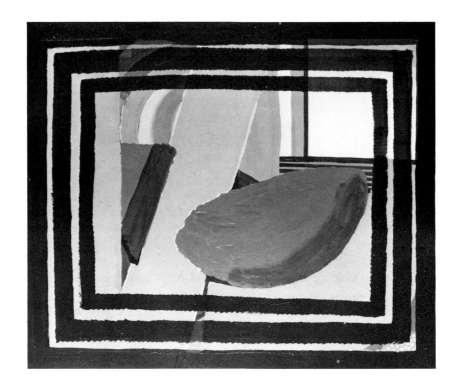

On the Terrace 1971–74
(not exhibited)
107 × 126

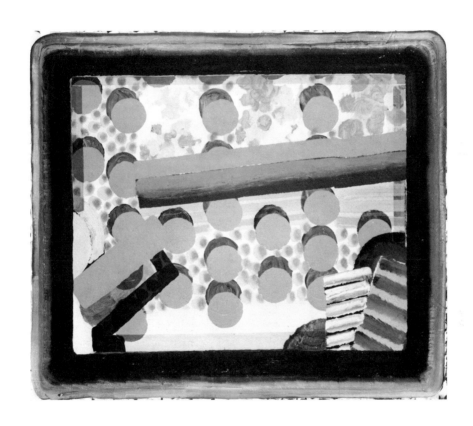

Cafeteria at the Grand Palais 1975
124.5 × 144.8 (156)

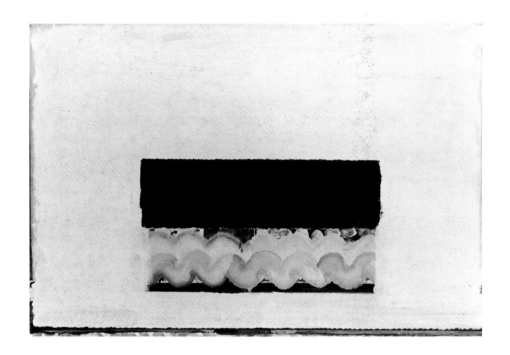

Ellen Smart's Indian Slide Show 1974–76
(not exhibited)
73 × 107

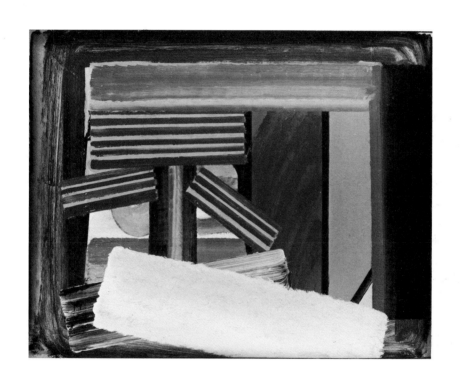

Foy Nissen's Bombay 1975–77
71.1 × 91.5 (155)

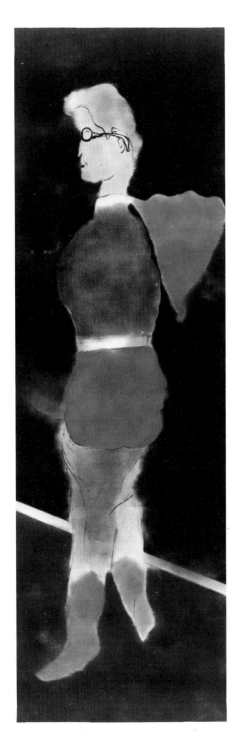 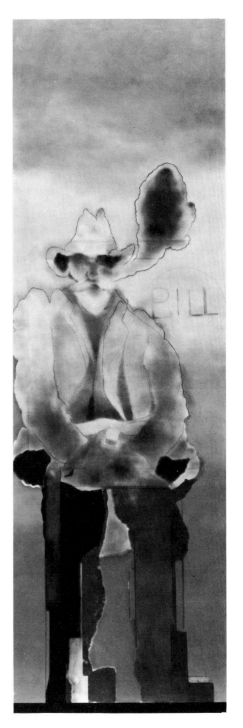

Left
Superman 1972
243 × 76 (160)

Right
Bill at Sunset 1973
243 × 76 (161)

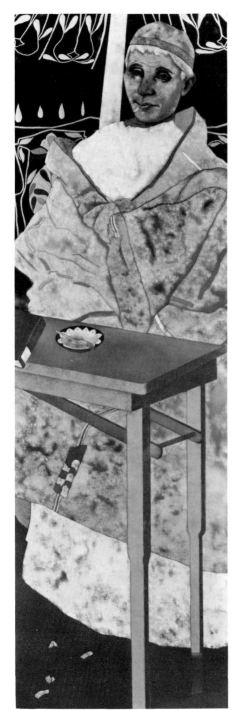

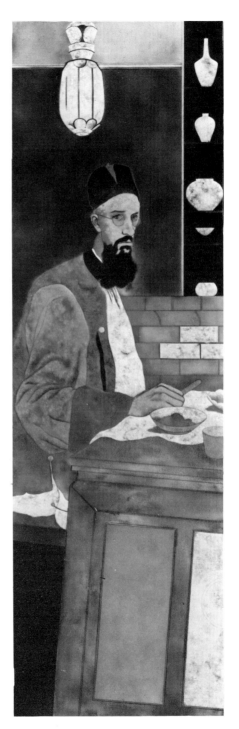

Left
Moresque 1976–77
243 × 76 (166)

Right
The Orientalist 1976–77
243 × 76 (165)

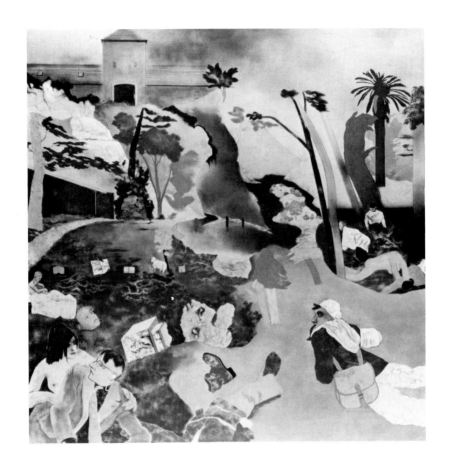

If Not, Not 1976
152 × 152
(not exhibited)

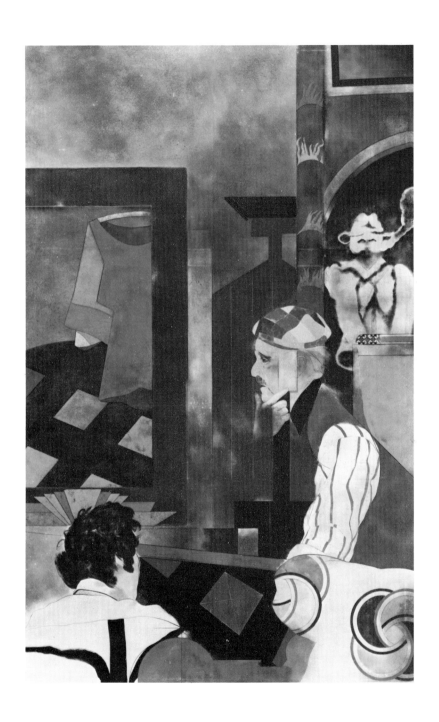

Kenneth Anger and Michael Powell 1973
243 × 76 (162)

Castle XXXVI 1976
152.5 × 160 (172)

Castle XLI 1976
152.5 × 160 (173)

Castle XLIII 1976
152.5 × 160 (175)

Castle XLIV 1976
152.5 × 160 (176)

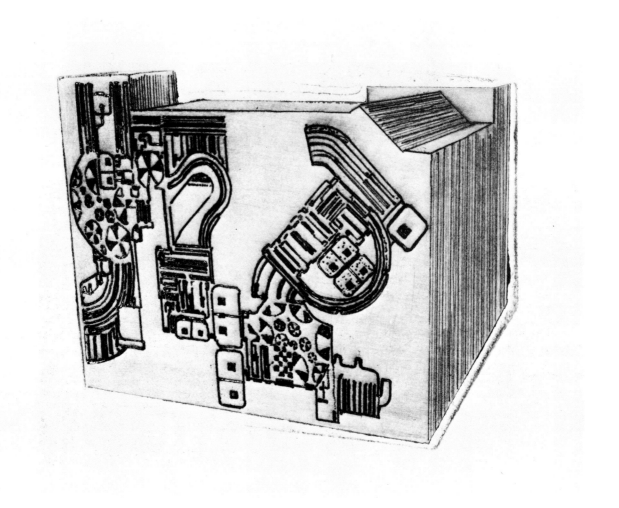

Kurfürstenstrasse 87
Woodcut 10 × 12.5 (185)

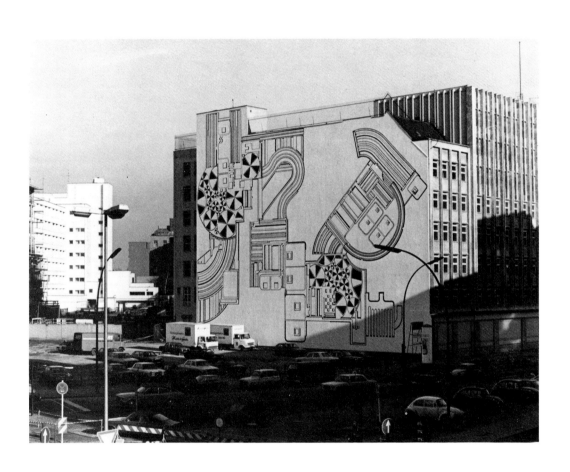

Mural on city centre wall Kurfürstenstrasse 87
990 sq. metres

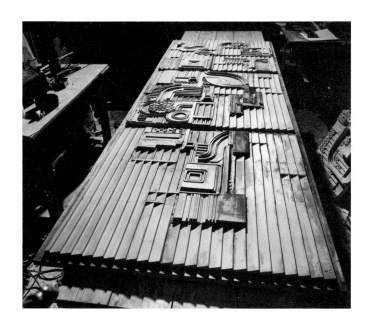

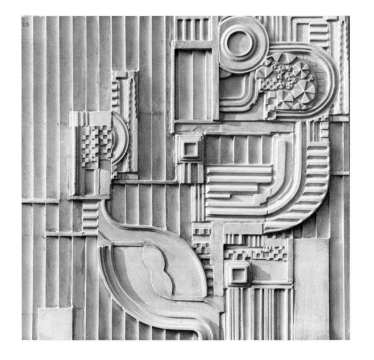

Top
Door 2 of Doors to Hunterian Gallery
365.7 × 91.4

Bottom
Panel 2B of Doors to Hunterian Gallery

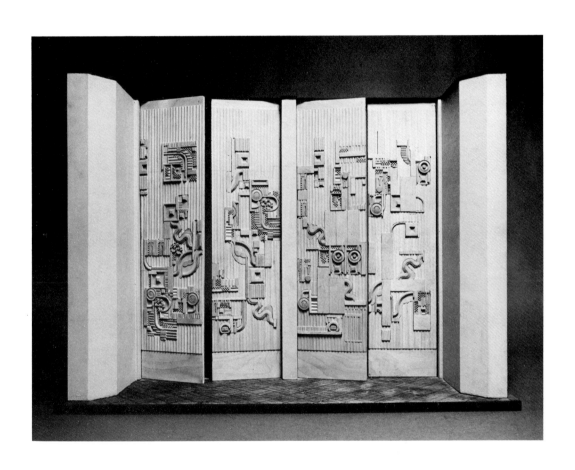

Working model for Doors to Hunterian Gallery
(not exhibited)

Each performance lasts one hour

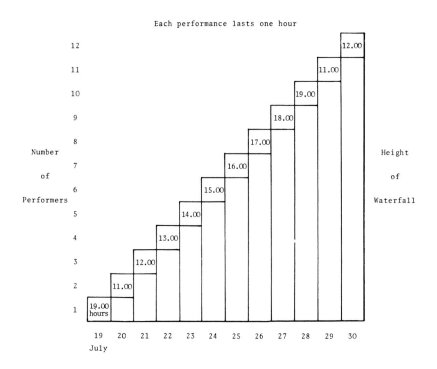

Number of Performers

12
11
10
9
8
7
6
5
4
3
2
1

| 12.00 |
| 11.00 |
| 19.00 |
| 18.00 |
| 17.00 |
| 16.00 |
| 15.00 |
| 14.00 |
| 13.00 |
| 12.00 |
| 11.00 |
| 19.00 hours |

19 20 21 22 23 24 25 26 27 28 29 30
July

Height of Waterfall

A WATERFALL

THE THEATRE OF MISTAKES

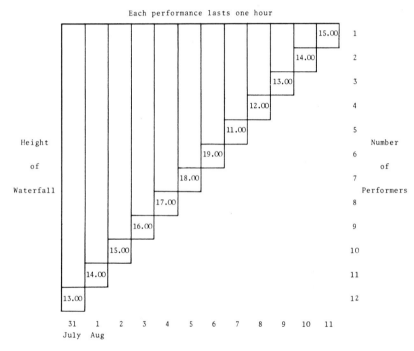

Each performance lasts one hour

Height

of

Waterfall

Number

of

Performers

```
                                                                    15.00  1
                                                              14.00        2
                                                        13.00              3
                                                  12.00                    4
                                            11.00                          5
                                      19.00                                6
                                18.00                                      7
                          17.00                                            8
                    16.00                                                  9
              15.00                                                       10
        14.00                                                            11
  13.00                                                                  12
```

31 1 2 3 4 5 6 7 8 9 10 11
July Aug

Each performance lasts one hour

	1	16.00 hours											
	2		17.00										
	3			18.00									
	4				19.00								
Number	5					11.00							
of	6						12.00						
Performers	7							13.00					
	8								14.00				
	9									15.00			
	10										16.00		
	11											17.00	
	12												18.00

Height

of

Waterfall

12 13 14 15 16 17 18 19 20 21 22 23
Aug

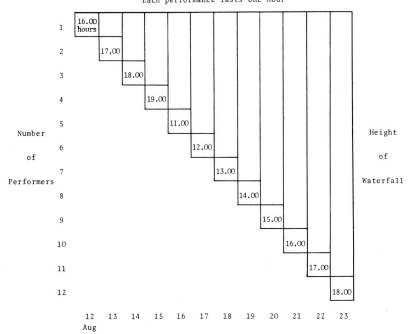

Each performance lasts one hour

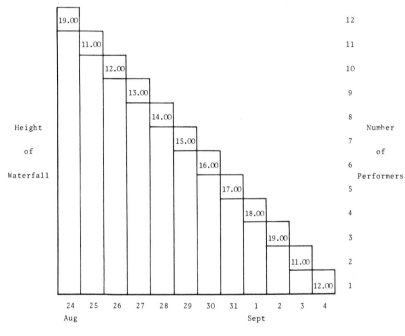

	19.00											12	
		11.00										11	
			12.00									10	
				13.00								9	
					14.00							8	
Height						15.00						7	Number
of							16.00					6	of
Waterfall								17.00				5	Performers
									18.00			4	
										19.00		3	
											11.00	2	
												12.00	1

24 25 26 27 28 29 30 31 1 2 3 4
Aug Sept

Catalogue
Part One

Note: measurements are given in centimetres, height first.

FRANK AUERBACH
b. 1931

1
Head of J.Y.M. 1974
Oil on board
71 × 61
Lent by T. R. Eyton

2
Reclining Head of J.Y.M. 1975
Oil on board
71 × 61
Private collection

3
Head of J.Y.M. 1975–76
Oil on board
50.8 × 45.8
Private collection

4
Portrait of J.Y.M. Seated 1976
Oil on double board
50.8 × 45.8
Marlborough Fine Art (London) Ltd

5
Portrait of Sandra 1974
Mixed media
77.5 × 56
Lent by R. B. Kitaj

6
Head of Brigid 1974
Chalk on paper
56 × 77.5
Arts Council Collection

7
Head of Brigid 1975
Chalk on paper
76.2 × 57.2
Private collection

8
Reclining Nude 1975
Mixed media
57.2 × 76.2
Private collection

9
Tree at Tretire with Geese 1975
Chalk on paper
76.2 × 75
Lent by Brigid Campbell

10
Summer at Tretire 1975
Chalk on paper
72.5 × 77.5
Private collection

11
Head of Bruce Bernard 1975
Chalk on paper
56 × 78.2
Marlborough Fine Art (London) Ltd

12
Head of Michael Podro 1976
Chalk on paper
57.2 × 76.2
Lent by D. A. Podro

13
Head of Michael Podro 1976
Chalk on paper
76.2 × 57.2
Marlborough Fine Art (London) Ltd

14
Head of Christopher Couch 2 1976
Oil on paper
77.5 × 57.2
Marlborough Fine Art (London) Ltd

15
Reclining Nude 1976–77
Chalk on paper
56 × 78.2
Marlborough Fine Art (London) Ltd

16
Reclining Nude 1976–77
Chalk on paper
56 × 78.2
Marlborough Fine Art (London) Ltd

ANTHONY CARO
b. 1924

17
Tundra 1975
Steel
272 × 551 × 223.5
Lent by T. M. and P. M. Caro

18
Footprint 1975
Steel
216 × 302 × 167
Lent by the Artist

PATRICK CAULFIELD
b. 1936

19
Villa Plage 1970
Acrylic on canvas
366 × 152.4
Waddington and Tooth Galleries Ltd

20
Foyer 1973
Acrylic on canvas
213.5 × 213.5
Waddington and Tooth Galleries Ltd

21
In My Room 1974
Acrylic on canvas
274.5 × 274.5
Lent by Sydney and Francis Lewis

22
Paradise Bar 1974
Acrylic on canvas
274.5 × 213.5
Virginia Museum of Fine Arts

23
Father's Day 1975
Acrylic on canvas
91.5 × 61
Private collection

24
Mother's Day 1975
Acrylic on canvas
91.5 × 61
Lent by Leslie Waddington

25
Study of Roses 1976
Acrylic on canvas
91.4 × 76.1
National Westminster Bank Ltd

26
Food and Drink 1977
Acrylic on canvas
186.5 × 152.3
Langan's Brasserie

27
Un gran bell'arrosto 1977
Acrylic on canvas
91.5 × 61
Waddington and Tooth Galleries Ltd

BERNARD COHEN
b. 1933

28
Representative 1974
Acrylic on linen canvas
274 × 137
Waddington and Tooth Galleries Ltd

29
Long Song 1974
Acrylic on linen canvas
244 × 244
Waddington and Tooth Galleries Ltd

30
Somewhere Between 1975
Acrylic on linen canvas
152 × 305
Waddington and Tooth Galleries Ltd

31
Resting Place 1975
Acrylic on linen canvas
213.5 × 213.5
Waddington and Tooth Galleries Ltd

32
Things Seen 1975–77
Acrylic on linen canvas
182.9 × 182.9
Lent by the Artist

33
Meal 1975–77
Acrylic on linen canvas
91.4 × 182.9
Lent by Leslie and Ferriel Waddington

34
Largely Animal 1975–77
Acrylic on linen canvas
182.9 × 182.9
Private collection

35
Settings 1975–77
Acrylic on linen canvas
182.9 × 91.4
Private collection

HAMISH FULTON
b. 1946

36
ICELAND 1975
Mounted photographs with text and frame
274.3 × 97.5
Arts Council collection

37
EVEREST LHOTSE 1975
Mounted photograph with text and frame
134.6 × 104.1
Lent by Anthony d'Offay

38
ARKLE 1976
Mounted photographs with text and frame
104 × 264
Robert Self Gallery

39
NEWFOUNDLAND 1976
Mounted photograph with text and frame
104.1 × 129.5
Robert Self Gallery

40
DYFED 1976
Mounted photograph with text and frame
104.1 × 129.5
Lent by the Artist

NIGEL HALL
b. 1943

41
Four 1976
Painted aluminium
251.4 × 222.4 × 83
Arts Council collection

42
Yellow Interior 1976
Painted aluminium
147.3 × 171.3 × 69
Felicity Samuel Gallery

43
Multiple Fracture I 1976
Painted aluminium
100.2 × 228.5 × 70
Lent by the Artist

44
Multiple Fracture II 1976
Painted aluminium
204.4 × 66 × 71.1
Lent by the Artist

45
Multiple Fracture III 1976
Painted aluminium
33 × 173 × 46.9
Lent by the Artist

JOHN HOYLAND
b. 1934

46
14.11.69
Acrylic on cotton duck
213.4 × 101.6
Lent by the Artist

47
27.5.71
Acrylic on cotton duck
213.4 × 366
Lent by the Artist

48
24.11.71
Acrylic on cotton duck
254 × 198.1
Waddington and Tooth Galleries Ltd

49
24.9.73
Acrylic on cotton duck
243.8 × 243.8
Lent by the Artist

50
17.5.75
Acrylic on cotton duck
228.6 × 203.2
Lent by the Artist

51
19.8.75
Acrylic on cotton duck
243.8 × 243.8
Lent by the Artist

52
24.5.76 (Seuil)
Acrylic on cotton duck
228.6 × 213.4
Waddington and Tooth Galleries Ltd

53
22.6.76 (Limen)
Acrylic on cotton duck
228.6 × 213.4
Lent by the Artist

54
23.9.76 (Vale)
Acrylic on cotton duck
228.6 × 203.2
Lent by the Artist

55
3.2.77 (Citar)
Acrylic on cotton duck
243.8 × 228.6
Lent by the Artist

56
14.2.77 (Terrace)
Acrylic on cotton duck
243.8 × 228.6
Waddington and Tooth Galleries Ltd

ALLEN JONES
b. 1937

57
Tall, Average, Petite 1975
Oil on canvas
183 × 366
Private collection

58
Eyes Front 1976
Oil on canvas
183 × 183
Lent by Leslie and Ferriel Waddington

59
Grand Opening 1976
Oil on canvas
244 × 122
Waddington and Tooth Galleries Ltd

60
Leopard 1976
Oil on canvas
183 × 122
Waddington and Tooth Galleries Ltd

61
Shi-Sen-Do 1976
Oil on canvas
183 × 305
Waddington and Tooth Galleries Ltd

62
X-Pose 1976
Oil on canvas
183 × 183
Waddington and Tooth Galleries Ltd

JOHN LATHAM
b. 1921

63
a AGE OVERS BINOW 1977
b 'Toward a Ph.D for Dogs' with the
assistance of Pippa O'Brien
Plinths with top surfaces
Lent by the Artist

64
TIME—BASE TAPE 1971
Lent by the Artist

KIM LIM
b. 1936

65
Column 1971–72
Stainless steel
137.1 × 58.8 × 21.5
Lent by the Artist

66
Intervals I 1973
Wood
182.8
Lent by the Artist

67
Intervals IIa 1973
Wood
182.8
Lent by the Artist

68
Intervals IIb 1973
Wood
182.8
Lent by the Artist

69
Intervals IIc 1973
Wood
182.8
Lent by the Artist

70
Intervals IIe 1973
Wood
182.8
Lent by the Artist

71
Stack 1976
Wood
87.5 × 126.9
Lent by the Artist

72
Link I 1975
Acrylic and Wood
length 365
Lent by the Artist

73
Link II 1975
Wood
length 335
Lent by the Artist

74
Link III 1976
Acrylic and wood
length 365
Lent by the Artist

75
Interstices I 1974–75
Wood
longest section 302.2
Lent by the Artist

76
Interstices II 1977
Wood
289.5
Lent by the Artist

77
Interstices III 1977
Wood
289.5
Lent by the Artist

78
Five works on paper 1976
Paper/Tonosawa
Each 43.1 × 44.2
Lent by the Artist

79
Drawing 1972
Ink and gouache
96.5 × 6.2
Lent by the Artist

KENNETH MARTIN
b. 1905

80
Chance and Order 6 (blue) 1970
Oil on canvas
91.5 × 91.5
Lent by Leslie and Ferriel Waddington

81
Chance and Order 18 (black) 1974
Oil on canvas
91.5 × 91.5
Waddington and Tooth Galleries Ltd

82
Chance and Order 19 (black and red) 1975
Oil on canvas
91.5 × 91.5
Waddington and Tooth Galleries Ltd

83
Chance, Order, Change 1 (fifteen colours)
1976
Oil on canvas
122 × 122
Lent by Leslie and Ferriel Waddington

84
Chance, Order, Change 2 (ultramarine blue)
1976
Oil on canvas
91.5 × 91.5
Arts Council Collection

85
Chance, Order, Change 3 (black) 1977
Oil on canvas
91.5 × 91.5
Lent by the Artist

86
Order and Change (black) 1977
Oil on canvas
91.5 × 91.5
Lent by the Artist

87
Series of drawings commenced July 1976
Each 41.9 × 29.8
Lent by the Artist

88
Metamorphoses 1977
Series of nine drawings
Each 25.3 × 20.3
Lent by the Artist

KEITH MILOW
b. 1945

89
F
GREEN
O
N
T 1976
Oil on wood
162.4 × 122 × 122
Lent by Baron Thilo von Watzdorf

90
R
GREEN
B
U
S 1976
Oil on wood
162.4 × 122 × 122
Nigel Greenwood Inc Ltd

91
R
E
B
ANNUL
S 1976
Oil on wood
162.4 × 122 × 122
Lent by Baron Thilo von Watzdorf

92
F
R
O
ANNUL
T 1976
Oil on wood
162.4 × 122 × 122
Nigel Greenwood Inc Ltd

93
TIJ92 DEFINITIVE 1977
Oil on wood
203.2 × 10.2 × 122
Nigel Greenwood Inc Ltd

94
SPLIT ƎVITINIⱯƎD 1977
Oil on wood
203.2 × 10.2 × 122
Nigel Greenwood Inc Ltd

95
SPLIT
ƎVITINIⱯƎD 1977
Oil on wood
203.2 × 10.2 × 122
Nigel Greenwood Inc Ltd

96
ⱢIⱢ92
DEFINITIVE 1977
Oil on wood
203.2 × 10.2 × 122
Nigel Greenwood Inc Ltd

NICHOLAS MONRO
b. 1936

97
Maquette for King Kong 1971–72
Black painted fibreglass
100.2 × 86.3 × 60.9
Wolverhampton Art Gallery and Museums

98
King Kong 1972
Reinforced coloured fibreglass
550 high
Lent by Spook Erection

99
Latin American Formation Team 1972
Fibreglass
187.9 × 759.3 × 121.9
Waddington and Tooth Galleries Ltd

100
Waiters Race 1975
Fibreglass
226 × 761 × 182.8
Lent by the Artist

101
Dude Cowboy 1976
Fibreglass
195.5 × 126.9 × 40.6
Lent by Alan Power

102
Samurai Warrior 1976
Fibreglass
210.8 × 116.8 × 81.2
Lent by Alan Power

PETER PHILLIPS
b. 1939

103
Art-O-Matic/Cudacutie 1972
Acrylic on canvas
200 × 400
Lent by Bruno Bischofberger, Zürich

104
Art-O-Matic/Loop di Loop 1972
Acrylic on canvas
200 × 400
Galerie Bischofberger, Zürich

105
Mosaikbild 6 × 12 1974
Oil on canvas
182 × 365
Waddington and Tooth Galleries Ltd

106
La Doré 5 × 4 1975
Oil on canvas
200 × 150
Waddington and Tooth Galleries Ltd

107
Mosaikbild/Displacements 1976
Acrylic on canvas
220 × 230
Lent by the Artist

108
No Focus Frames 1976–77
Oil on canvas
220 × 120
Lent by the Artist

109
Carnival 1977
Oil on canvas
220 × 120
Lent by the Artist

WILLIAM TURNBULL
b. 1922

110
Random 1971–72
Wood
10.1 × 276.8 × 380
Lent by the Artist

111
Steps 1967–72
Stainless steel
91.4 × 91.4 × 101.5
Lent by the Artist

112
No. 5 – 1973
Acrylic on canvas
177.7 × 177.7
Waddington and Tooth Galleries Ltd

113
No. 18 – 1974
Acrylic on canvas
152.3 × 114.2
Lent by the Artist

114
No. 9 – 1975
Acrylic on canvas
203.1 × 203.1
Waddington and Tooth Galleries Ltd

115
No. 3 – 1976
Acrylic on canvas
177.7 × 177.7
Waddington and Tooth Galleries Ltd

116
No. 11 – 1976
Acrylic on canvas
177.7 × 177.7
Lent by the Artist

117
No. 12 – 1976
Acrylic on canvas
152.3 × 152.3
Lent by the Artist

118
No. 13 – 1976
Acrylic on canvas
152.3 × 152.3
Lent by the Artist

119
No. 14 – 1976
Acrylic on canvas
152.3 × 152.3
Lent by the Artist

Catalogue
Part Two

Note: measurements are given in centimetres, height first.

PETER BLAKE
b. 1932

120
David Hockney in a Hollywood-Spanish
Interior, commenced 1964
Cryla on canvas
182.9 × 152.4
Waddington and Tooth Galleries Ltd

121
Sword Fight, commenced 1964
Cryla on canvas
182.9 × 304.8
Waddington and Tooth Galleries Ltd

122
Tarzan, Jane, Boy and Cheetah at the Roxy
Cinema, New York, commenced 1964
Cryla on canvas
182.9 × 152.4
Waddington and Tooth Galleries Ltd

123
Puck, Peaseblossom, Cobweb, Moth and
Mustardseed, commenced 1969
Cryla on hardboard
99.1 × 76.2
Waddington and Tooth Galleries Ltd

124
Titania, commenced 1976
Oil on canvas
121.9 × 91.4
Waddington and Tooth Galleries Ltd

STUART BRISLEY
b. 1933

125
Measurement and Division 1977

STEPHEN BUCKLEY
b. 1944

126
Akenside 1974
Oil on canvas
157.4 × 178.2
Kasmin Limited

127
La Manche 1974
Oil on canvas
182.8 × 426
Kasmin Limited

128
Head of a Young Girl No. 7 1975
Oil on canvas
208.2 × 170.1
Kasmin Limited

129
Dancers 1975
Oil on canvas
152.3 × 253.9 × 10.1
Kasmin Limited

*A selection of new work is also included in this
exhibition*

VICTOR BURGIN
b. 1941

130
Possession 1976
Poster
118.9 × 84.1
Public freehold (published by the Robert Self Gallery)

MICHAEL CRAIG-MARTIN
b. 1941

131
Installation 1977

ROBYN DENNY
b. 1930

132
Travelling 1 1976–77
Oil on canvas
213.4 × 182.8
Waddington and Tooth Galleries Ltd

133
Travelling 2 1976–77
Oil on canvas
213.4 × 182.8
Waddington and Tooth Galleries Ltd

134
Travelling 3 1976–77
Oil on canvas
213.4 × 182.8
Waddington and Tooth Galleries Ltd

135
Travelling 4 1976–77
Oil on canvas
213.4 × 182.8
Waddington and Tooth Galleries Ltd

136
Travelling 5 1976–77
Oil on canvas
213.4 × 182.8
Waddington and Tooth Galleries Ltd

BARRY FLANAGAN
b. 1941

137
Hayward Installation III 1977

ANTHONY HILL
b. 1930

138
The Nine – Hommage à Khlebnikov No. 1
1975
Relief and engraved formica
81 × 81
Arts Council Collection

139
The Nine – Hommage à Khlebnikov No. 2
1976
Relief structure (octagonal)
91.4 × 91.4
Kasmin Limited

140 .
The Nine – Hommage à Khlebnikov No. 3
1976
Relief and engraved formica
91.4 × 91.4
Lent by the Artist

141
Linear Obstruction 1972–77
Relief and engraved formica
121.9 × 121.9
Lent by the Artist

142
Small Rebis 1976–77
Relief – formica
58.4 × 53.3
Lent by the Artist

143
Kupka's Tower (Rebis Series) 1976–77
Relief – formica
81 × 76
Lent by the Artist

144
Large Rebis 1976–77
Relief and engraved formica
81 × 76
Lent by the Artist

145
Linear Rebis 1976–77
Engraved formica
81 × 76
Lent by the Artist

JOHN HILLIARD
b. 1945

146
Untitled 1975–77
Three mounted colour photographs
Each (approx.) 60.9 × 81.2
Lent by the Artist

147
Untitled 1975–77
Three mounted colour photographs
Each (approx.) 60.9 × 81.2
Lent by the Artist

148
Untitled 1975–77
Three mounted colour photographs
Each (approx.) 60.9 × 81.2
Lent by the Artist

149
Untitled 1975–77
Three mounted colour photographs
Each (approx.) 60.9 × 81.2
Lent by the Artist

DAVID HOCKNEY
b. 1937

150
Model with Unfinished Self-portrait 1977
Oil on canvas
152 × 152
Kasmin Limited

151
Self-portrait with Blue Guitar 1977
Oil on canvas
152 × 183
Kasmin Limited

152
The Blue Guitar
A portfolio of etchings 1976–77
Each 35 × 42.5
An edition of 200
Published by the Petersburg Press

'I read Wallace Stevens' poem and made some
drawings last summer on Fire Island. It seemed to
express something I felt about my own work at the time.
The etchings themselves weren't conceived as literal
illustrations of the poem but as an interpretation of its
themes in visual terms. Like the poem, they're about the
transformation within art as well as the relation
between reality and the imagination, so there are
pictures within pictures and different styles of
representation juxtaposed and reflected and dissolved
within the same frame, this "hoard of destructions"
that Picasso talked about . . .'

HOWARD HODGKIN
b. 1932

153
Hopes at Home 1973–77
Oil on wood
91.5 × 106.7
Kasmin Limited

154
Mr and Mrs P.K. 1973–77
Oil on wood
91.5 × 106.7
Waddington and Tooth Galleries Ltd

155
Foy Nissen's, Bombay 1975–77
Oil on wood
71.1 × 91.5
Arts Council Collection

156
Cafeteria at the Grand Palais 1975
Oil on wood
124.5 × 144.8
Private collection

157
Tea with Mrs Parikh 1974–77
Oil on wood
30.5 × 36.8
Kasmin Limited

158
Small Simon Digby 1977
Oil on wood
31.8 diameter
Waddington and Tooth Galleries Ltd

R. B. KITAJ
b. 1932

159
Still (The Other Woman) 1972
Oil on canvas
243 × 76
Private Collection

160
Superman 1972
Oil on canvas
243 × 76
Private Collection

161
Bill at Sunset 1973
Oil on canvas
243 × 76
Private Collection

162
Kenneth Anger and Michael Powell 1973
Oil on canvas
243 × 76
Wallraf – Richartz Museum, und Museum Ludwig,
Cologne

163
Not exhibited

164
The Jew etc. 1976–77
(second state)
Oil on canvas
152 × 122
Lent by the Artist

165
The Orientalist 1976–77
Oil on canvas
243 × 76
Marlborough Fine Art (London) Ltd

166
Moresque 1976–77
Oil on canvas
243 × 76
Marlborough Fine Art (London) Ltd

167
Untitled 1976–77
(unfinished)
Oil and charcoal on canvas
182 × 152
Lent by the Artist

168
After Lorenzetti 1976–77
Oil on canvas
152 × 152
Marlborough Fine Art (London) Ltd

169
Smyrna Greek (Nikos) 1976–77
Oil on canvas
243 × 76
Marlborough Fine Art (London) Ltd

170
Frankfurt Brothel 1977
Oil on canvas
122 × 152
Marlborough Fine Art (London) Ltd

171
Slav Soul 1977
Oil on canvas
243 × 76
Marlborough Fine Art (London) Ltd

BOB LAW
b. 1934

172
Castle XXXVI 1976
Acrylic and ballpen on cotton duck
152.5 × 160
Lent by the Artist

173
Castle XLI 1976
Acrylic and ballpen on cotton duck
152.5 × 160
Lent by the Artist

174
Castle XLII 1976
Acrylic and ballpen on cotton duck
152.5 × 160
Lent by the Artist

175
Castle XLIII 1976
Acrylic and ballpen on cotton duck
152.5 × 160
Lent by the Artist

176
Castle XLIV 1976
Acrylic and ballpen on cotton duck
152.5 × 160
Lent by the Artist

177
That Certain Smile I 1977
Acrylic on cotton duck
152.5 × 160
Lent by the Artist

EDUARDO PAOLOZZI
b. 1924

178
Four doors, Entrance to Hunterian
Gallery 1976–77
Cast aluminium
Each door 365.7 × 91.4
Hunterian Gallery, Glasgow

Original competition entry for a mural on a
city centre wall in Kurfürstenstrasse 87
(Budapester Str.) West Berlin, Germany
179
Model 1976
Wood and paper
28 × 61 × 61
Lent by the Artist
180
Cartoon 1976
Paper (dyeline)
120 × 156
Lent by the Artist
181
Photograph of the mural in
Kurfürstenstrasse 87. The wall is
an area of 990 square metres.

Models for "Forum Metall" a commissioned
project in cast iron to commemorate the
Brückner Festival, Linz, Austria 1977

182a
Model
Plaster
13 × 20 × 5 (without base)
Lent by the Artist

182b
Model
Plaster
25 × 37 × 8 (without base)
Lent by the Artist

183
Study for Brückner Sculpture,
Linz, Austria 1977
Charcoal on paper
49.6 × 70.5
Lent by the Artist

184
Study for Brückner Sculpture,
Linz, Austria 1977
Charcoal on paper
49.6 × 70.5
Lent by the Artist

185
Kurfürstenstrasse 87
Woodcut
10 × 12.5
Lent by the Artist

186
Kurfürstenstrasse 87
Woodcut
7 × 8.5
Lent by the Artist

187
Four Doors, Entrance to Hunterian Gallery
Woodcut
14 × 9.6
Lent by the Artist

188
Four Doors, Entrance to Hunterian Gallery
Woodcut
6.6 × 10
Lent by the Artist

189
Panel of the Glasgow Door
Woodcut
8 × 8.5
Lent by the Artist

THE THEATRE OF MISTAKES
Michael Greenall b. 1948
Anthony Howell b. 1945
Glenys Johnson b. 1952
Peter Strickland b. 1948
Fiona Templeton b. 1951

190
A Waterfall 1977
A waterfall for 1 to 5 performers was
originally conceived as the device for 'Two
Journeys'. At the Hayward, for the first time,
1 to 12 performers are employed in the piece.
Turn to the illustration pages for the times
and dates of the 48 performances. The
company would like to thank all those
taking part in the waterfall for their
co-operation.